Marlborough

New York
April 5 to May 5, 2001

London
August 2 to August 29, 2001

Monte Carlo
June 27 to August 31, 2002

Always Upping the Ante

by Phyllis Tuchman

Artist Dale Chihuly has, quite rightly, been compared to Merlin and other wizards, magicians, and shamans. Designer Jack Lenor Larsen has introduced him as, "among other things, a pied piper." And critic Barbara Rose has suggested that "he is something like an artistic Superman." But Chihuly has himself likened the role he assumes at his Seattle studio, where he maintains a state-of-the-art hotshop as well as a mock-up studio, archives, library, and photography facility, to that of a ship captain or a movie director.

As he works more and more in the public realm, Chihuly, who will turn sixty this September, is emerging as a glassblower who quite simply—though with the assistance of teams of international artisans—has elevated the status of his art. He is a Benvenuto Cellini for the new millennium. As he ingeniously marries color, glass, and metal to achieve the sort of awesome "Towers," "Moon," spikes of "Green Grass," "Spears," and "Crystal Mountain" that he exhibited from July 1999 through November 2000 at Jerusalem's Tower of David Museum, it is apparent that he thinks like a painter as well as a sculptor. His practice of draftsmanship and design to realize the way he balances, plants, and secures glass elements to steel armatures sets him apart as well. This lifelong resident of Washington State belongs among the creative geniuses who every few centuries defy inherited boundaries and conventions and end up reaching a wider public than usual, one ranging from the heads of state to the man and woman in the street. As curator Jack Cowart pointed out several years ago, "this artist seems always to be upping the ante, continually making things more difficult, both physically and intellectually, in the studio glass movement."

Dale Chihuly is to glass what Alexander Calder is to sculpture. Both men are huge talents who have dominated their areas of expertise. The former has maximized our regard for light; the latter, motion. Neither of these innovators ever rested on his laurels. Calder did more than invent the mobile; throughout a career spanning five decades, he continually introduced all sorts of original series, ranging from wire portraits to gargantuan-sized stabiles. Similarly, since the late 1970s, Chihuly has created one remarkable group of works of

beauty and splendor after another, and, in recent years, what he attains has become more and more complex as he focuses on multipart installations. If his "Macchia" series established a new standard for the way color can be expressed in glass, other objects of his reveal equally novel approaches with respect to unprecedented size, unusual shaping, and an astounding variety of textures.

The names Calder and Chihuly often evoke art that might seem fragile. Yet the opposite is true. Their work is much more durable than supposed—many of their pieces have been installed in all sorts of outdoor settings as well as large spaces inside various types of buildings. Both men also came to their careers circuitously via odd jobs and a love of travel—which, much later on, not only enhanced the way they have solved problems, but also led them to hold more expansive attitudes about the world at large. And this leads to their most striking connection: their audience. People who have never visited an art gallery, auction house, or major museum are familiar with work by these two men. They've either encountered it in person in a public place or discovered it by watching a program broadcast over television. Responding to the dazzling and joyful qualities of Calder's sculpture and Chihuly's glass, people often smile broadly. You see this again and again in the videos and DVDs made of Chihuly's installations over Venice and at Israel's Tower of David, and you will see this with visitors to his latest show. His glasswork has an ebullient tone that today is seldom encountered in other serious art.

When you look at Chihuly's radiant "Chandeliers," it's hard to picture this Tacoma-born and -raised artist as having come of age during the counterculture 1960s. He appears to have been a dropout who absorbed much during his time abroad. By traveling to Renaissance Florence, he set himself in a city where his every step put him in touch with the riches of the past—from piazzas filled with sculpture to checkered marble church facades to rusticated stone palazzi, not to mention the frescoed walls of apses, naves, and chapels, much less the halls of the Uffizi. Chihuly says he left Tuscany and went to Israel because he wasn't learning Italian. These days, it's obvious his eyes mastered the Old Masters of painting, sculpture, architecture, and the decorative arts. When he returned to Europe after graduate school, he focused next on how different countries developed their own unique histories of glass. He learned his lessons well. They've stuck with him for decades.

When asked about how he made his art, Dale Chihuly used to talk about sand and fire, the glassblower's basic recipe for success. Lately, he more typically mentions how "I work with four materials: glass, plastic, ice, and water." And he explains why. "These are," he says, "the only materials of any scale that are transparent. When you look at their transparency, what you are looking at is light itself. . . ." Formerly, Chihuly was describing how his "Baskets," "Cylinders," "Seaforms," "Macchia," "Floats," and other more individual series that rest directly on a table, the floor, or some other flat surface got realized at his Boathouse facilities. Now he focuses more intently on how smaller elements are brought together, often attached in some way, and used to create larger compositions.

To realize a Chihuly "Chandelier" or a "Tower," an armature of some sort must be devised. Decisions must be made regarding whether the openings from which the glass elements will be suspended will be wide or narrow. When loosely attached, parts will sway and strike the metal, adding sound to the overall experience of these enchanting structures. The worlds of design and sculpture meet as treelike, pyramidal, or cubic armatures are constructed. And then the light-attracting glass adds its pictorial punch via color and unfamiliar organic shapes that create a play between their exotic imagery and the neutrality of the metal anchoring them.

Chihuly knows his colors—how the properties of, say, cobalt blue will respond to its surroundings differently from, say, the attributes of cadmium yellow. If he mounts a large group of shapes on a circular structure, he realizes that strong, dark work might need to be distributed in a way unlike the one he would devise for paler elements. Depending on their pigmentation, the units might need to be clustered closer together or farther apart. Chihuly probably could have swapped shoptalk with Dan Flavin, who had much to say about his fluorescent light palette. But the Minimalist not only had a much reduced range of hues and tones with which to work; he was limited by where he could install his glass tubes and their containing pans. Chihuly, at this point, can work with a virtual cornucopia of color and, as has become increasingly obvious, he can lean, float, suspend, and in many other ways install his glass art outdoors as well as inside. The settings in which he places his works affect how all of their aspects are perceived.

Listen to Chihuly on the topic of his recent exhibition in Jerusalem: "Most of my installations in the past were designed for

museums and indoor applications and rely primarily on artificial lighting. And although we did ship and install some 200 lighting fixtures for night viewing, the primary viewing in the Citadel is of course during daylight hours. The sun is much brighter than any artificial sources so the colors seem much different. Certain colors look fantastic in the bright sun. . . . I chose pieces that would take the strong light . . . many colors won't."

Chihuly also knows how to take advantage of what he does not know. Anyone who has ever watched the video or DVD of "Chihuly Over Venice" has witnessed this facet of his enterprising personality. Wanting to push himself into uncharted waters, Chihuly and his wonderful team traveled to Finland, Ireland, Mexico, and Italy to pool their resources with like-minded teams of glassblowers. Chihuly was willing to temporarily relocate his team with such a vast group because he suspected good things might happen by bringing talented artisans together. Challenge them he did. And they all rose to the occasion. In one shop, he ended up with astonishing shapes and thicker glass than what everyone was accustomed to attaining; elsewhere, he got gorgeous crystal with wonderful etched surfaces; at the third facility, yet other shapes and amazing mirrored surfaces were produced. The visitors from Seattle as well as their hosts found their common language in the fires of the furnaces and the skills they brought to their mutual activity. Chihuly did not know this would happen. Nor did he have any idea how grateful everyone would feel about learning from one another new ways to do things. But he believed something positive would result. After all, glassmaking involves lots of faith in ineffables.

Lines and shapes are the vehicles for conveying Chihuly's sublime color. Yet, on their own, they are of interest and hold our attention independently. Working in the hotshops in Finland, Ireland, Mexico, and Italy, the team from Washington State considerably expanded their visual vocabularies. In this instance, travel was truly enlightening. Newly complex forms are now being brought together to realize astonishing aggregates of color—clustered as chandeliers, propped up as diagonal spikes resembling legions of honor guards, arrayed as unusual fields of saguaro-like forms, becoming waving towers that resemble burning bushes. A masterful impresario of color, light, shape, form, balance, composition, and rhythm, Dale Chihuly treats visitors to his exhibitions to mesmerizing images they have never before experienced in life—or art.

Catalog

31 **Dappled Orange Ikebana with Purple and Chartreuse Stems,** 2000, 62 x 30 x 23"

32 **Antwerp Blue Ikebana with Yellow and Red Stems,** 2001, 70 x 57 x 22"

33 **Antwerp Blue Ikebana with Yellow and Red Stems,** 2001, detail

34 **Meadow Green Ikebana with Red Stem and Leaf,** 2001, 61 x 55 x 40"

35 **Amber Ikebana with One Gold Stem,** 1992, 34 x 32 x 17"

36 **Exhibition View,** Marlborough Gallery, 2001

37 **Jerusalem 2000 Cylinder,** 2000, detail

38 **Jerusalem 2000 Cylinder,** 2000, 27 x 7 x 7"

39 **Gilded Blue Jerusalem Cylinder,** 2001, 27 x 22 x 22"

40 **Dark Rose Mottled Jerusalem Cylinder,** 2001, 21 x 19 x 19"

41 **Tangerine Jerusalem Cylinder,** 2001, 14 x 20 x 16"

44 **Ikebana Drawing,** 2000, 30 x 23"

45 **Burnt Drawing,** 1999, 42 x 30"

46 **Basket Drawing,** 2000, 60 x 40"

47 **Basket Drawing,** 2000, 42 x 30"

48 **Jerusalem Drawing,** 1999, 42 x 30"

49 **Macchia Drawing,** 1998, 42 x 30"

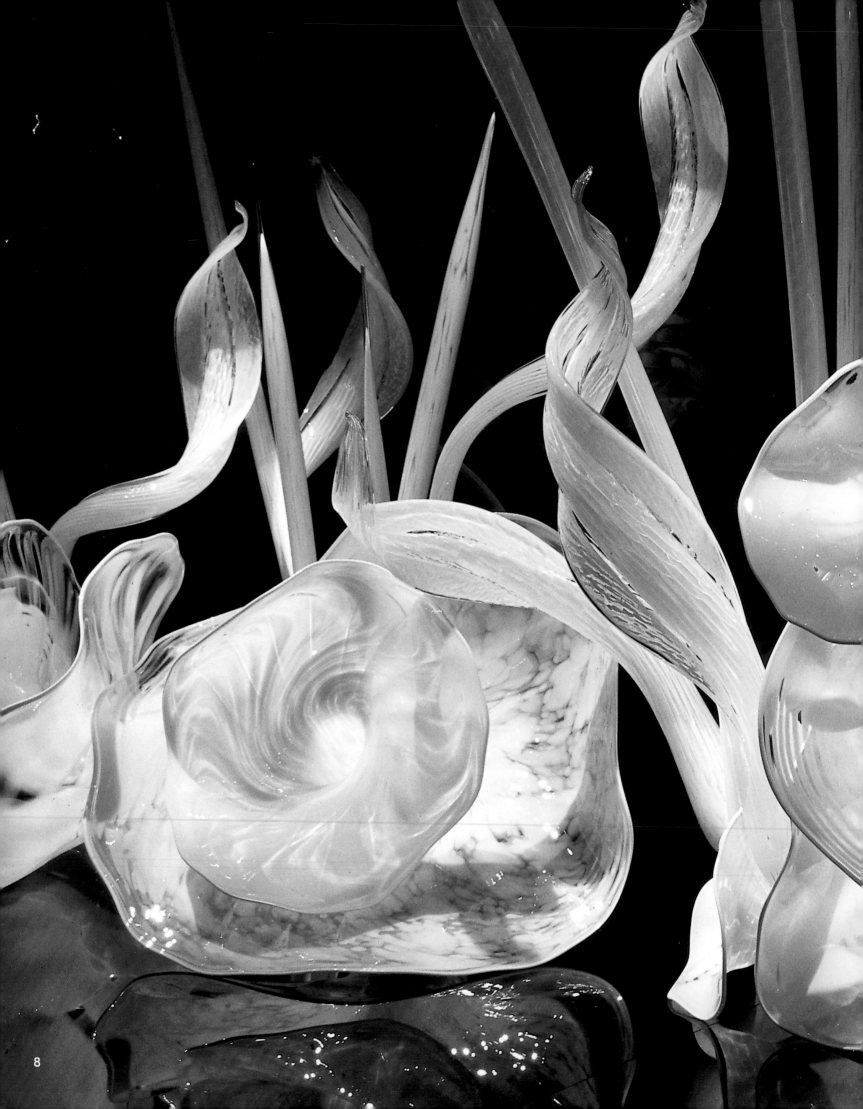

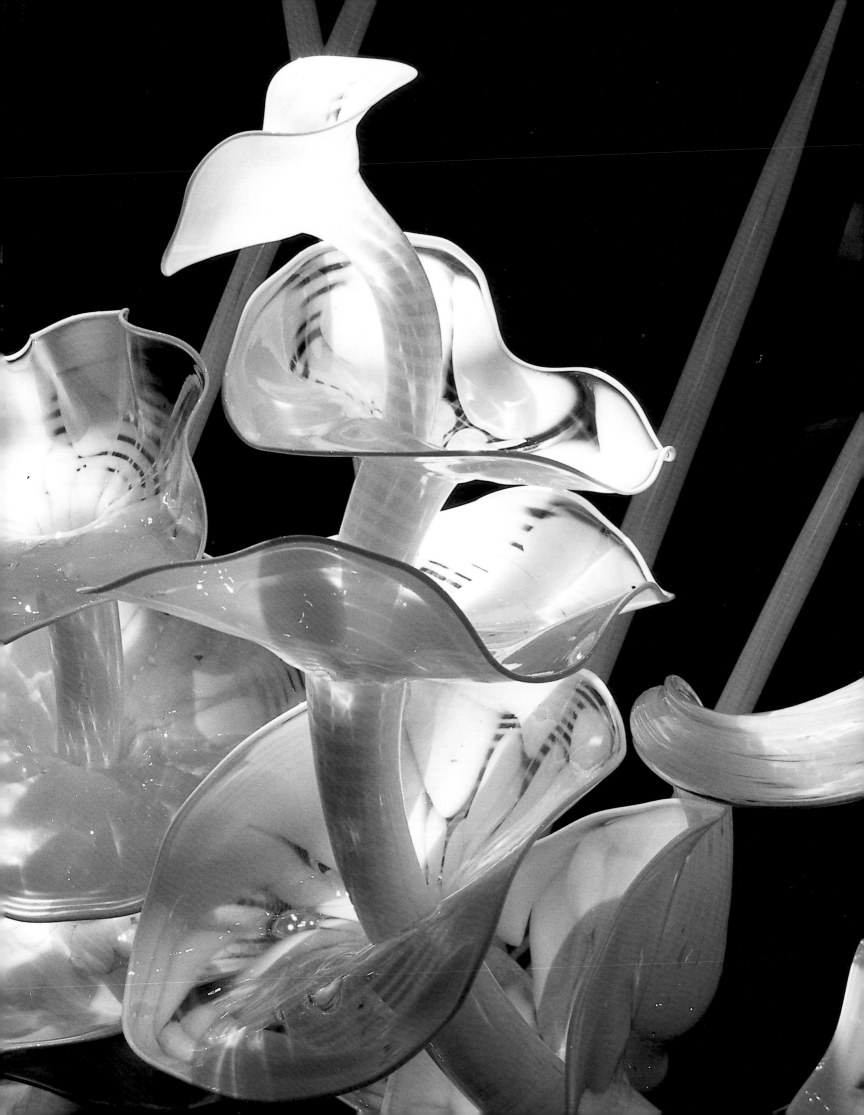

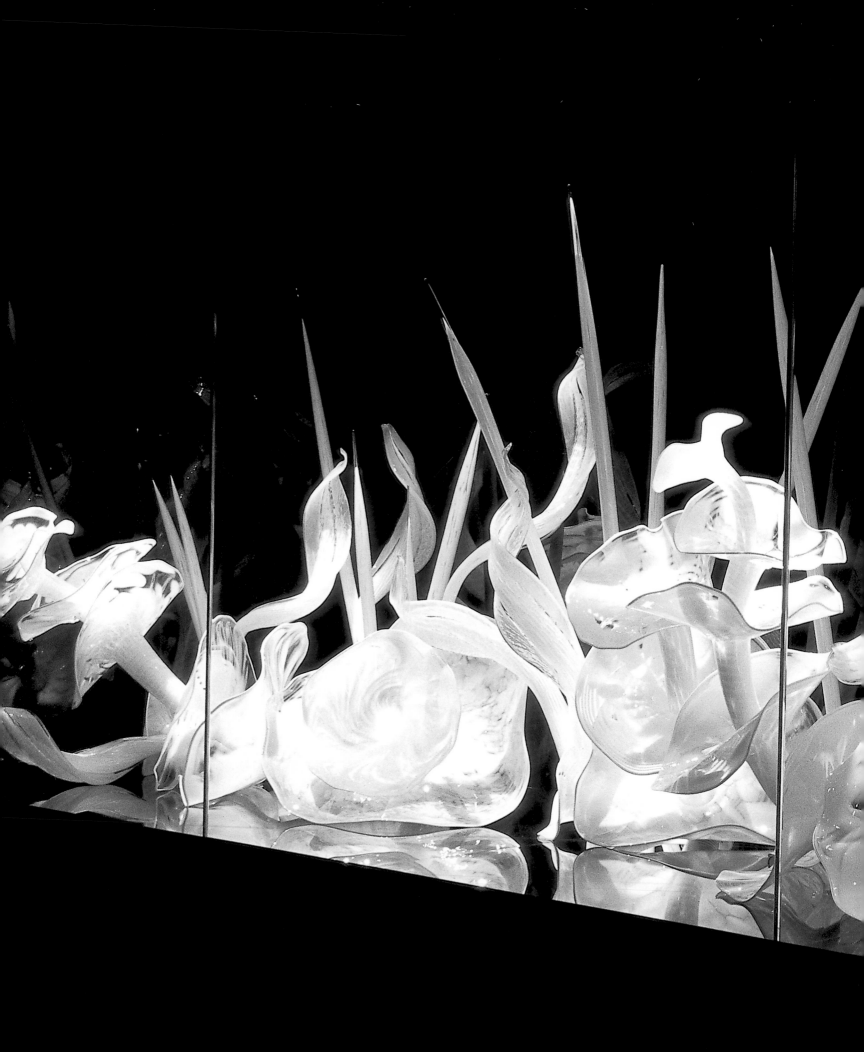

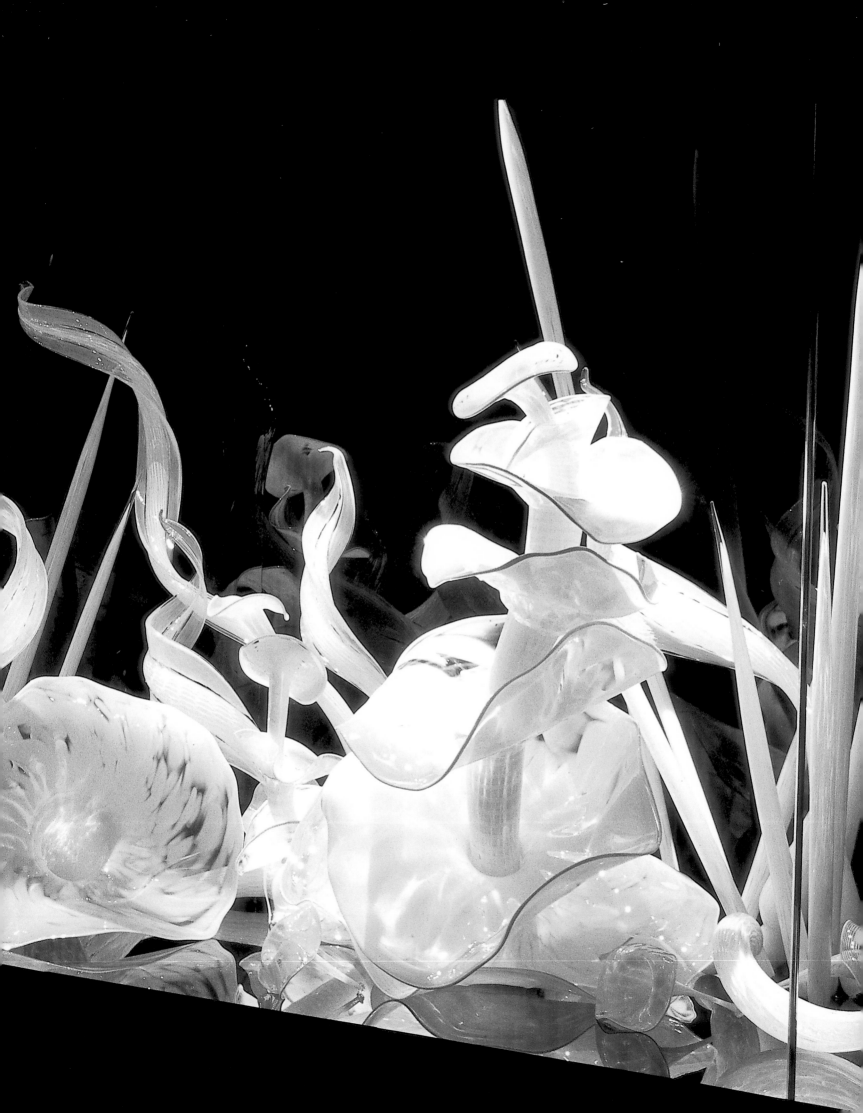

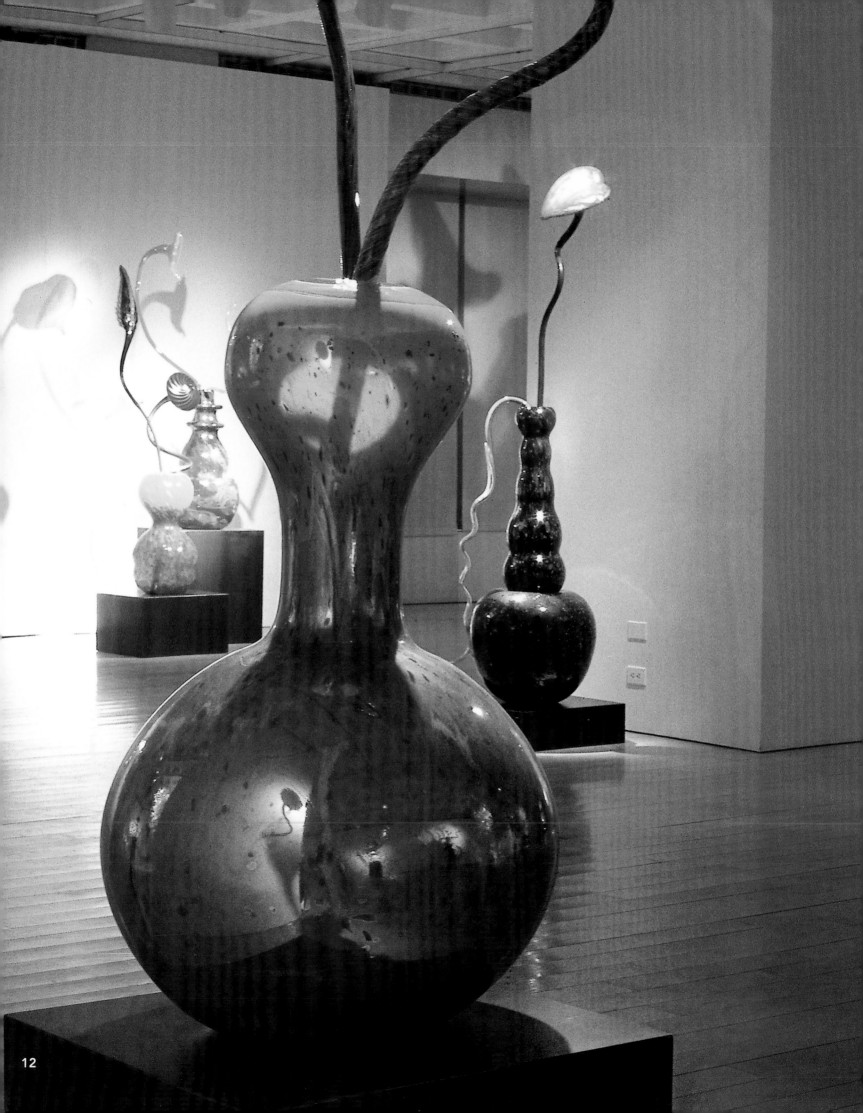

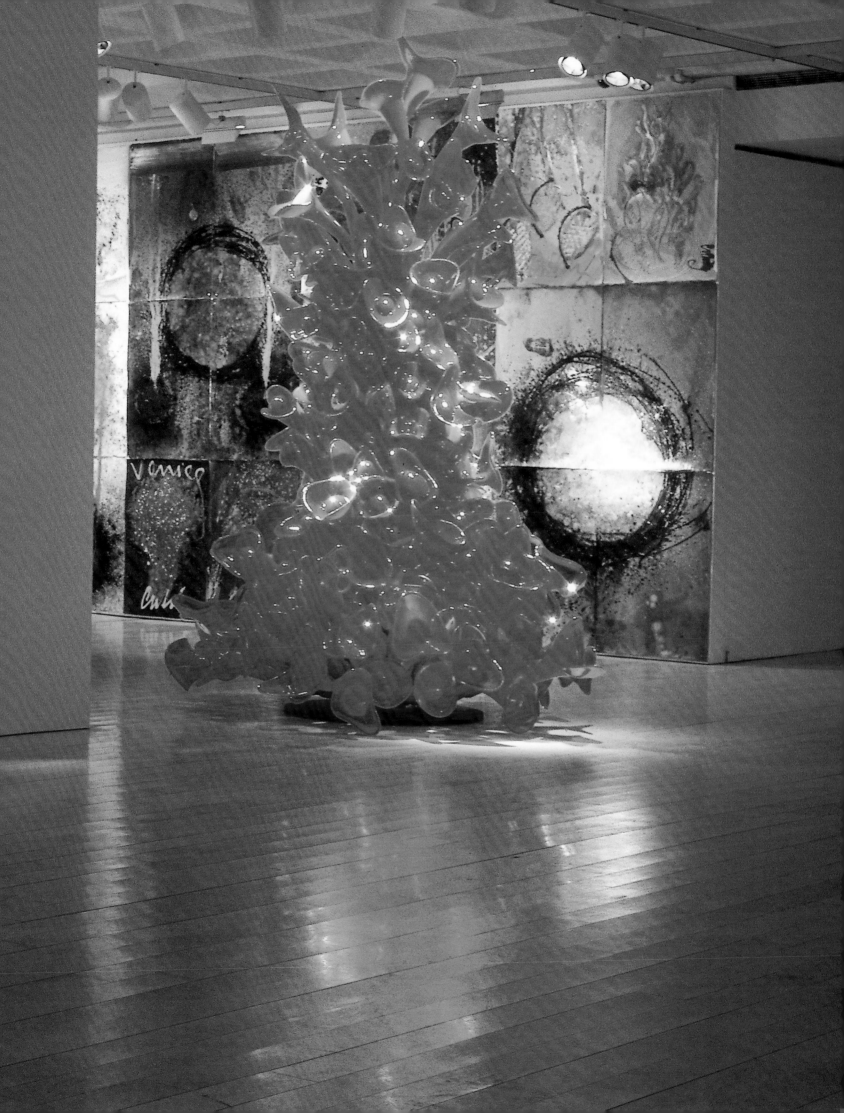

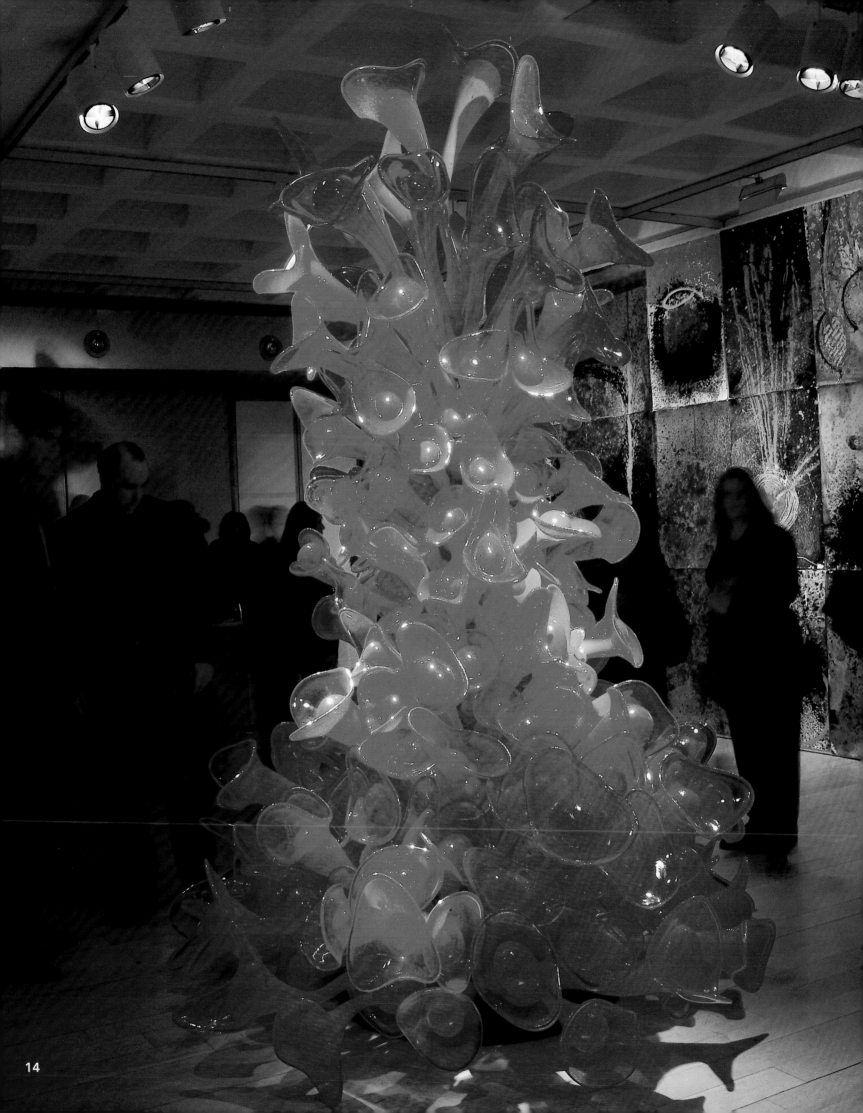

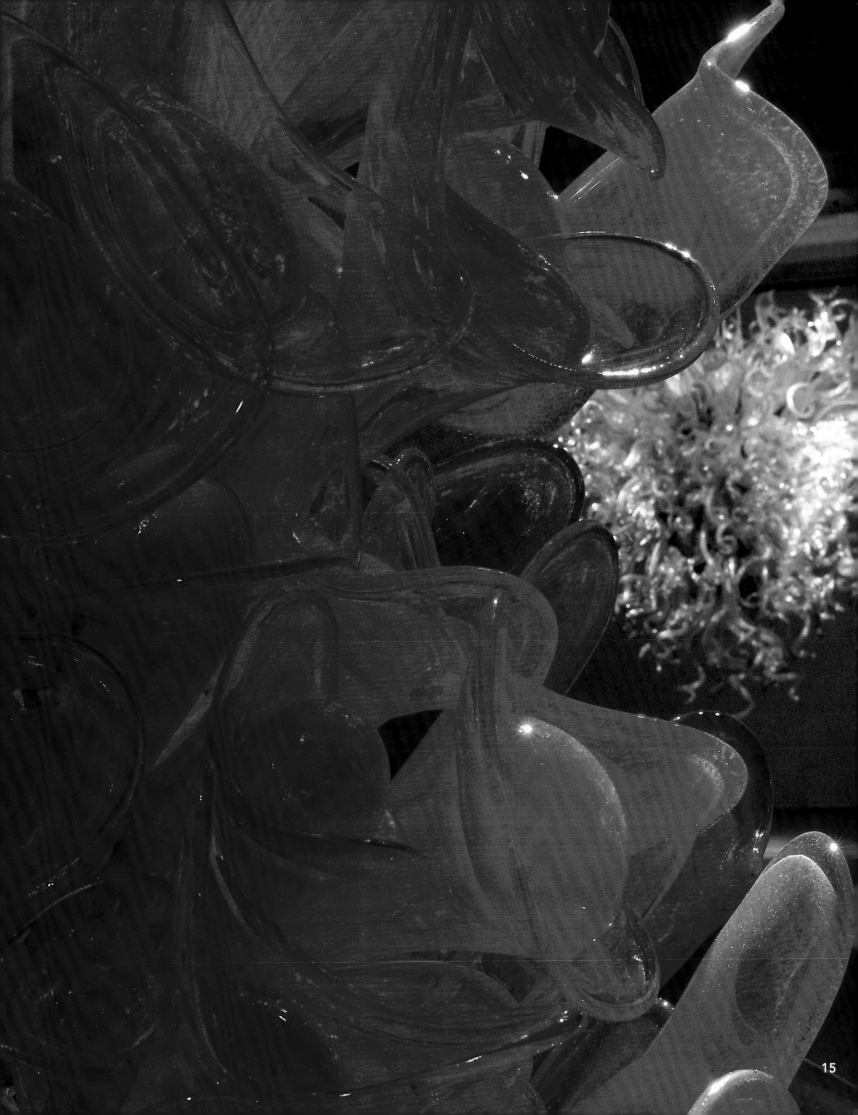

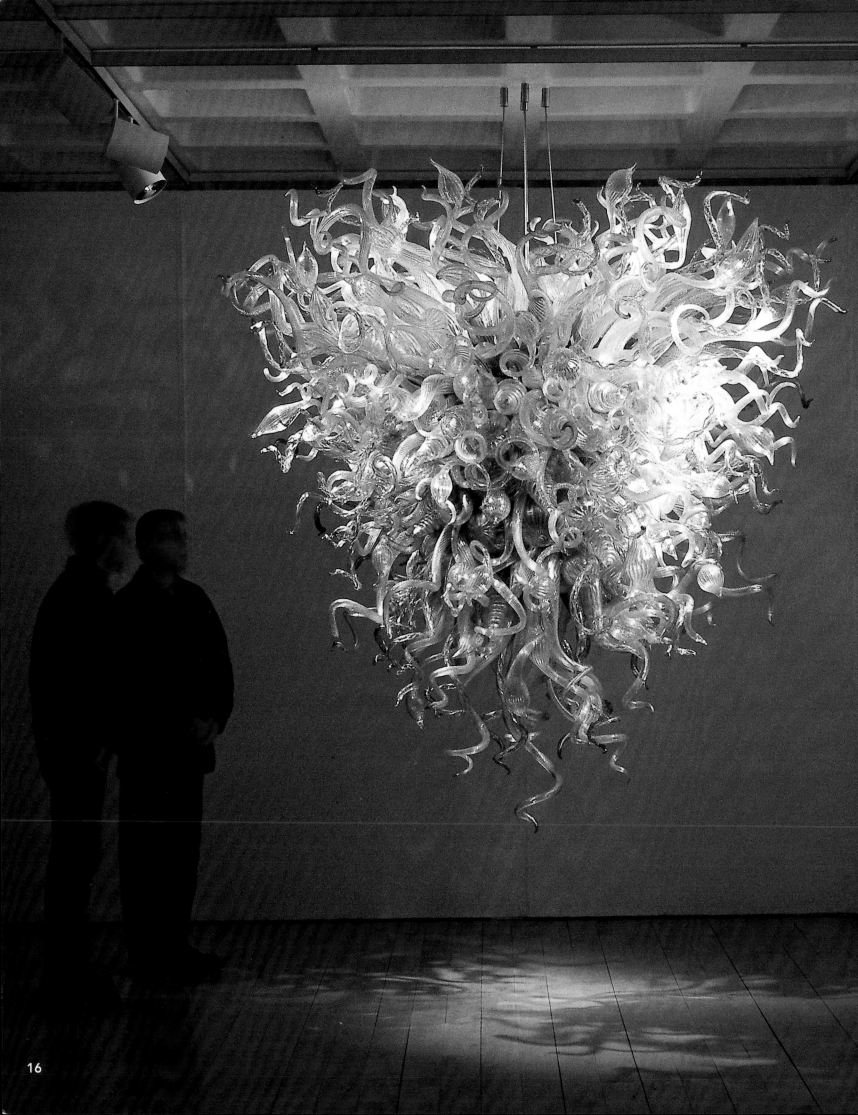

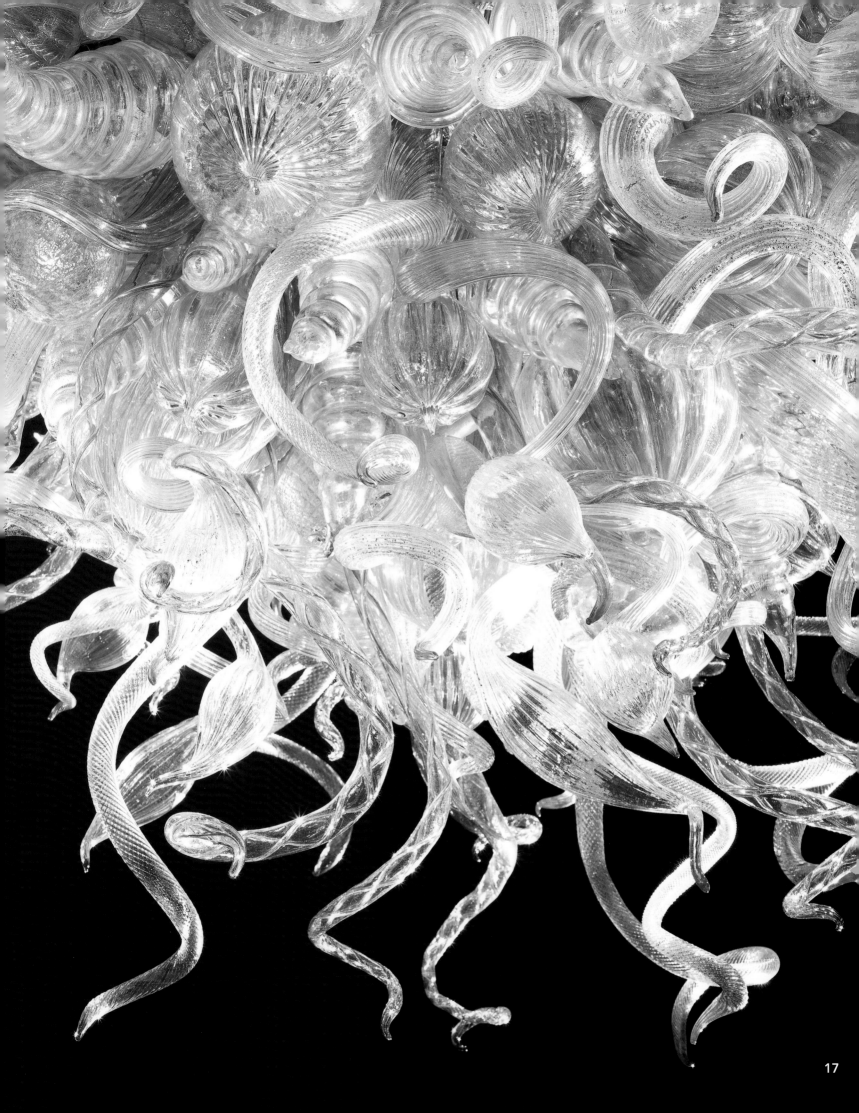

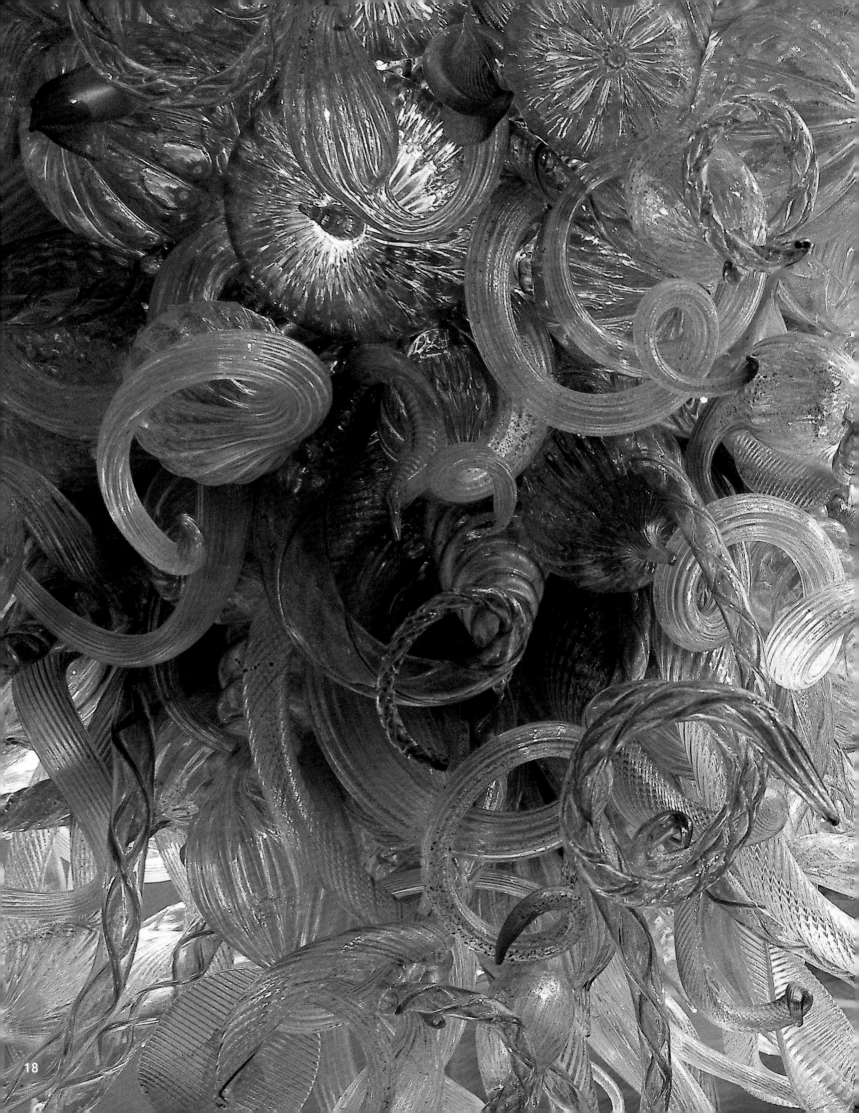

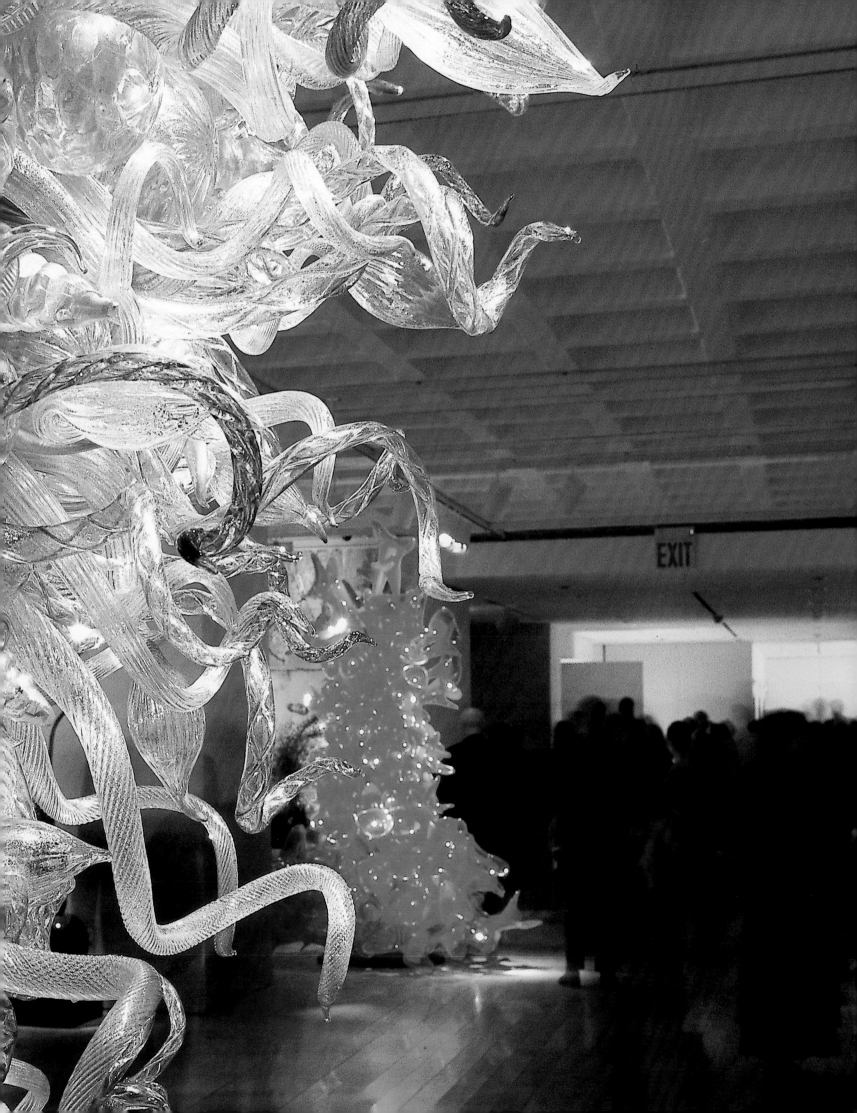

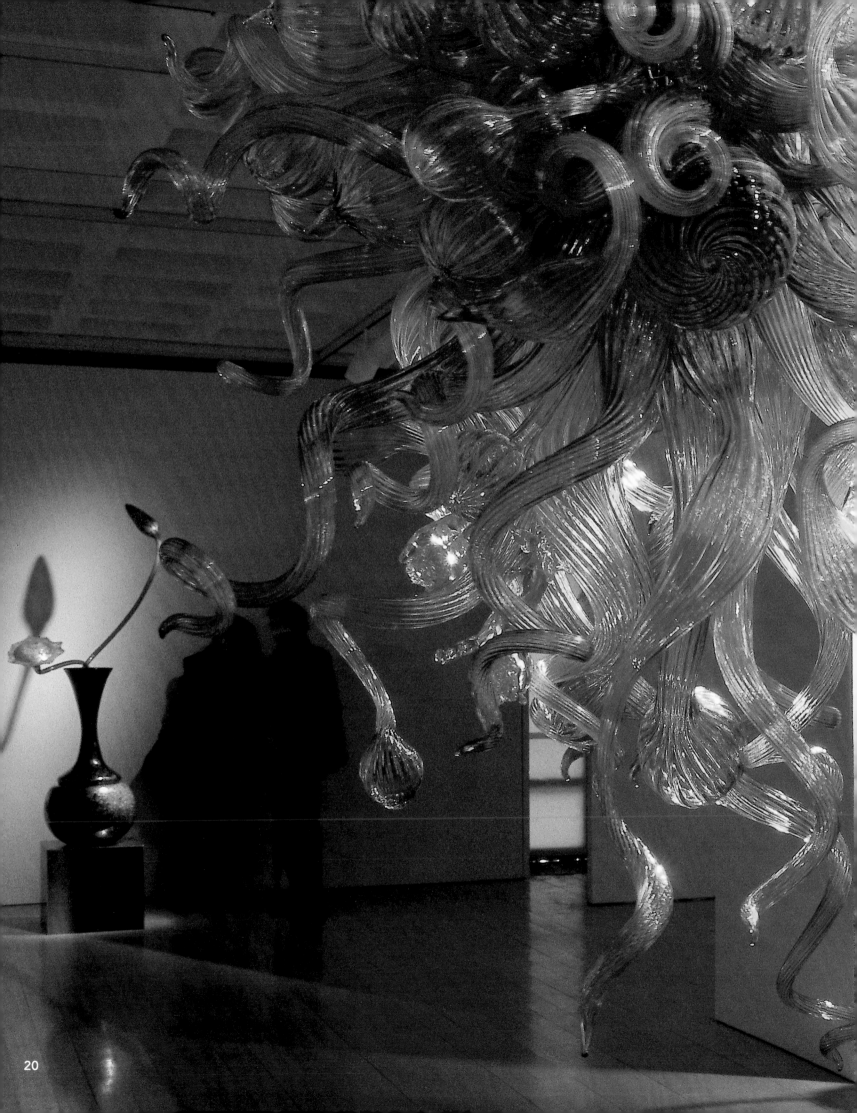

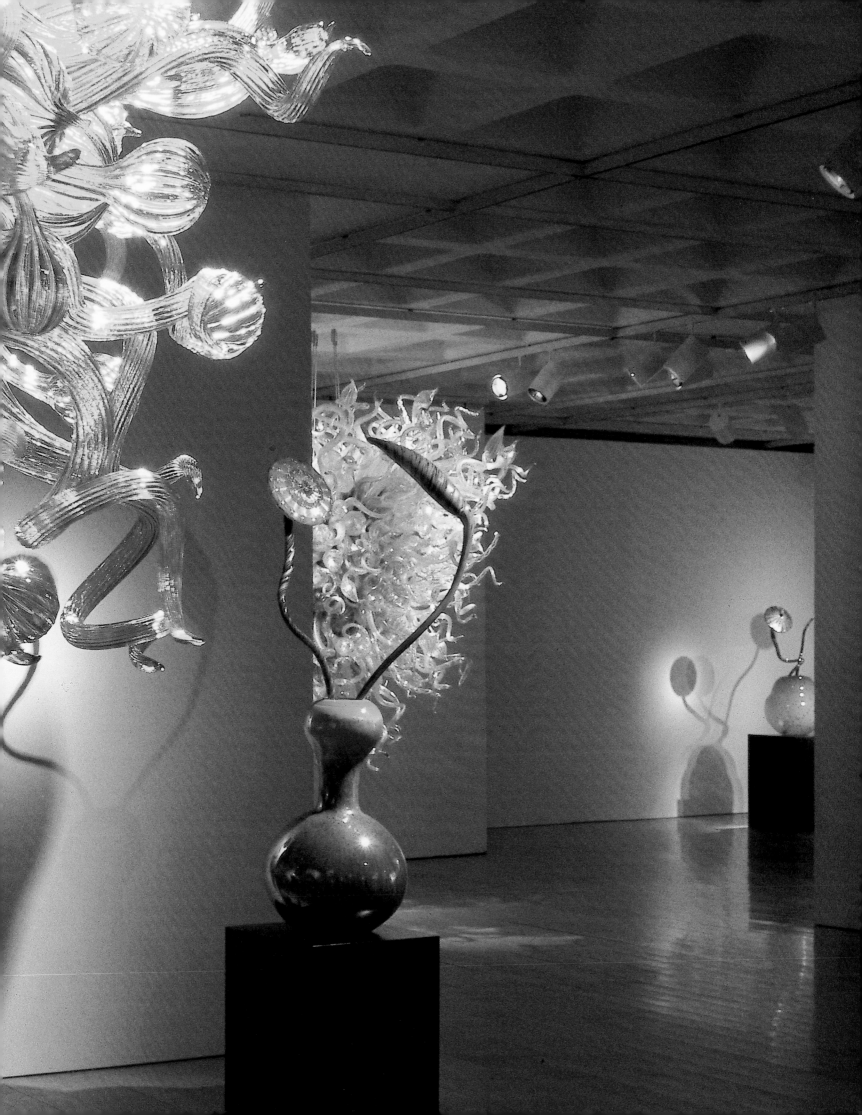

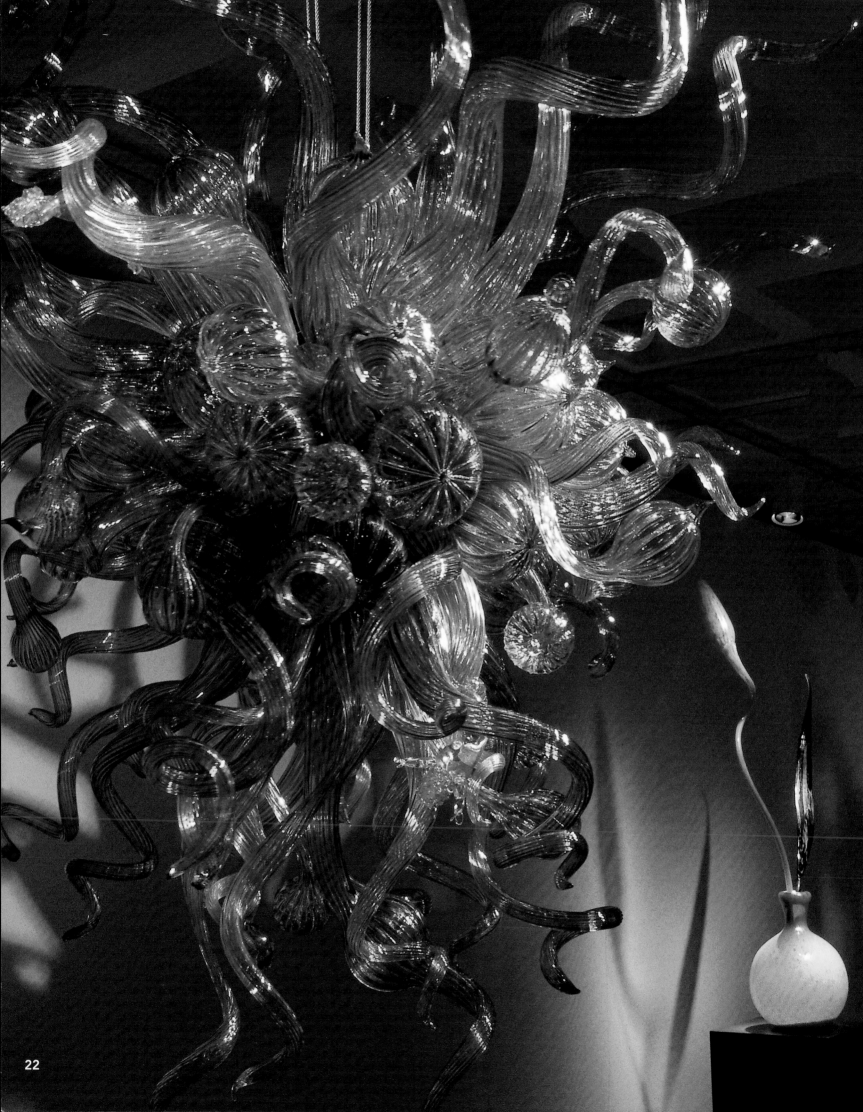

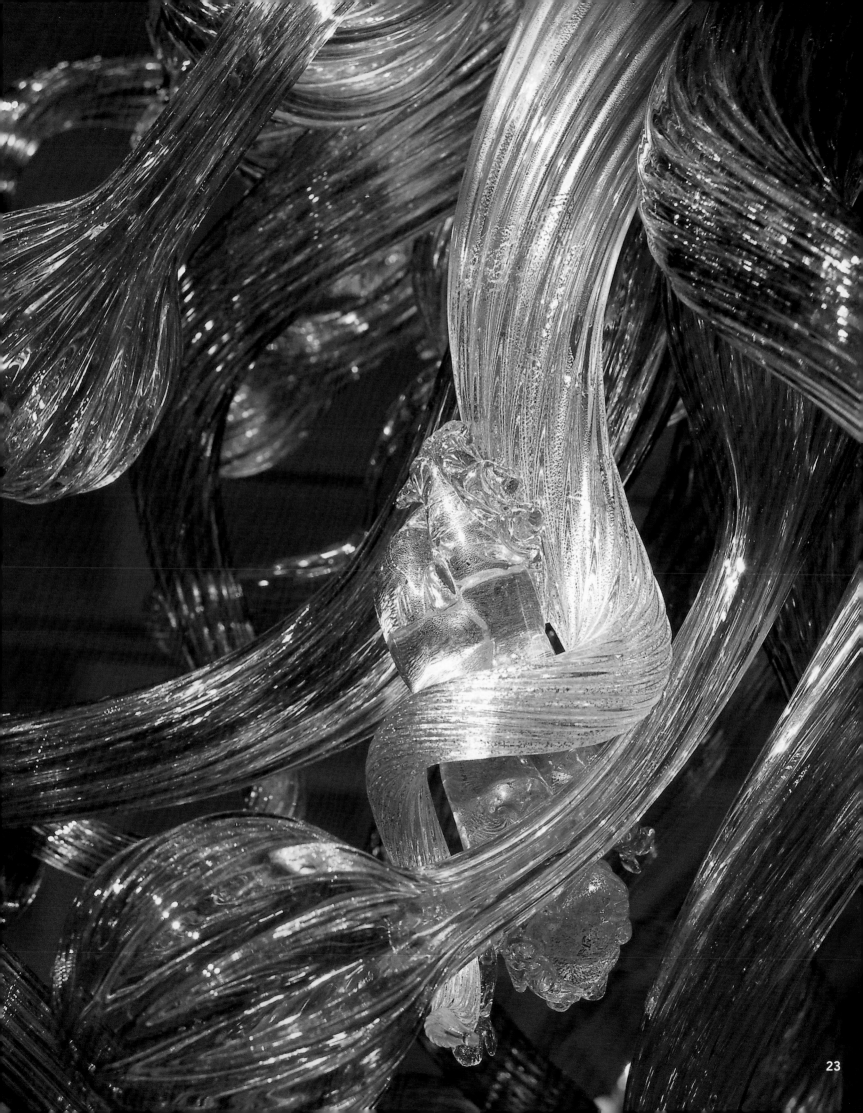

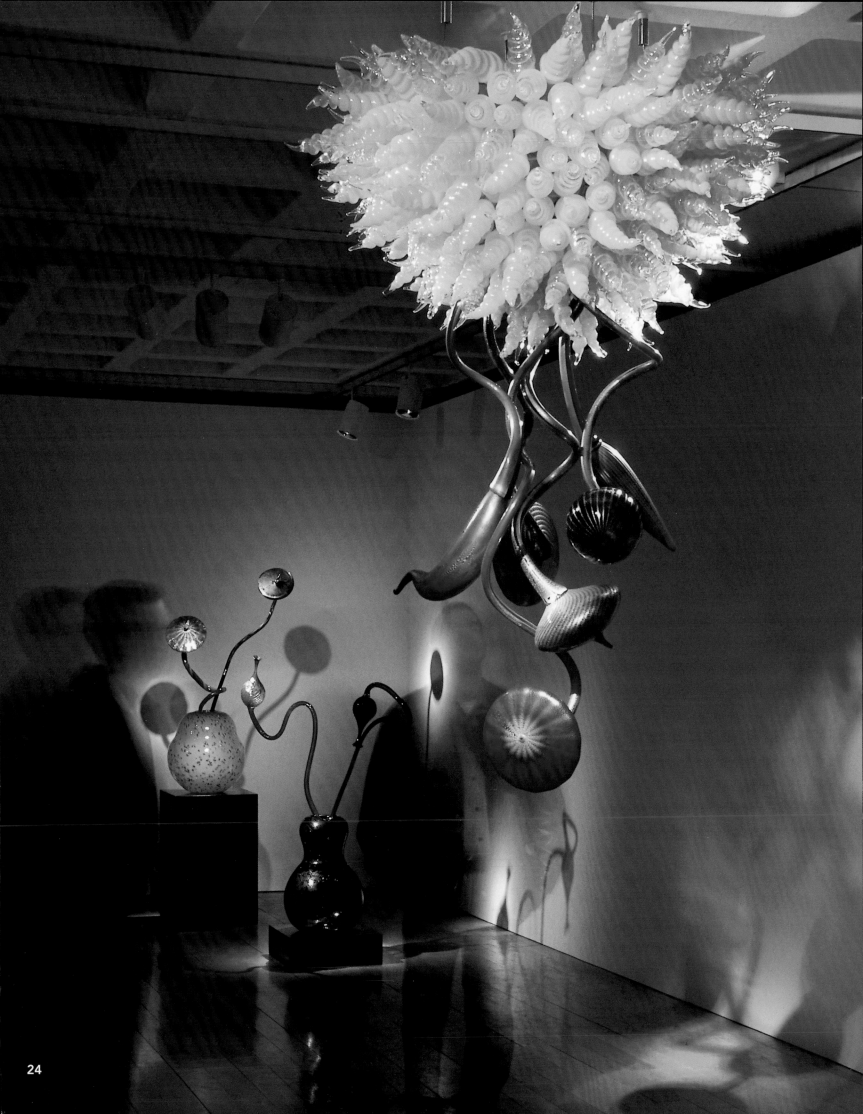

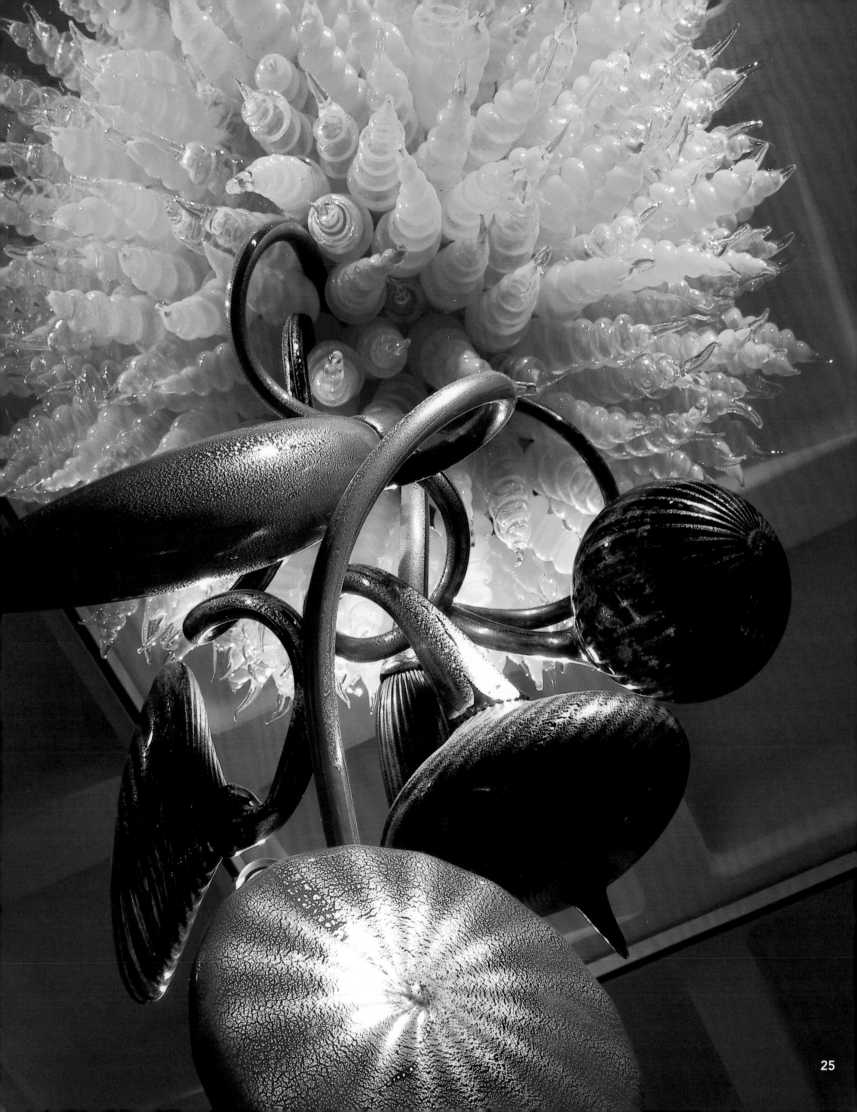

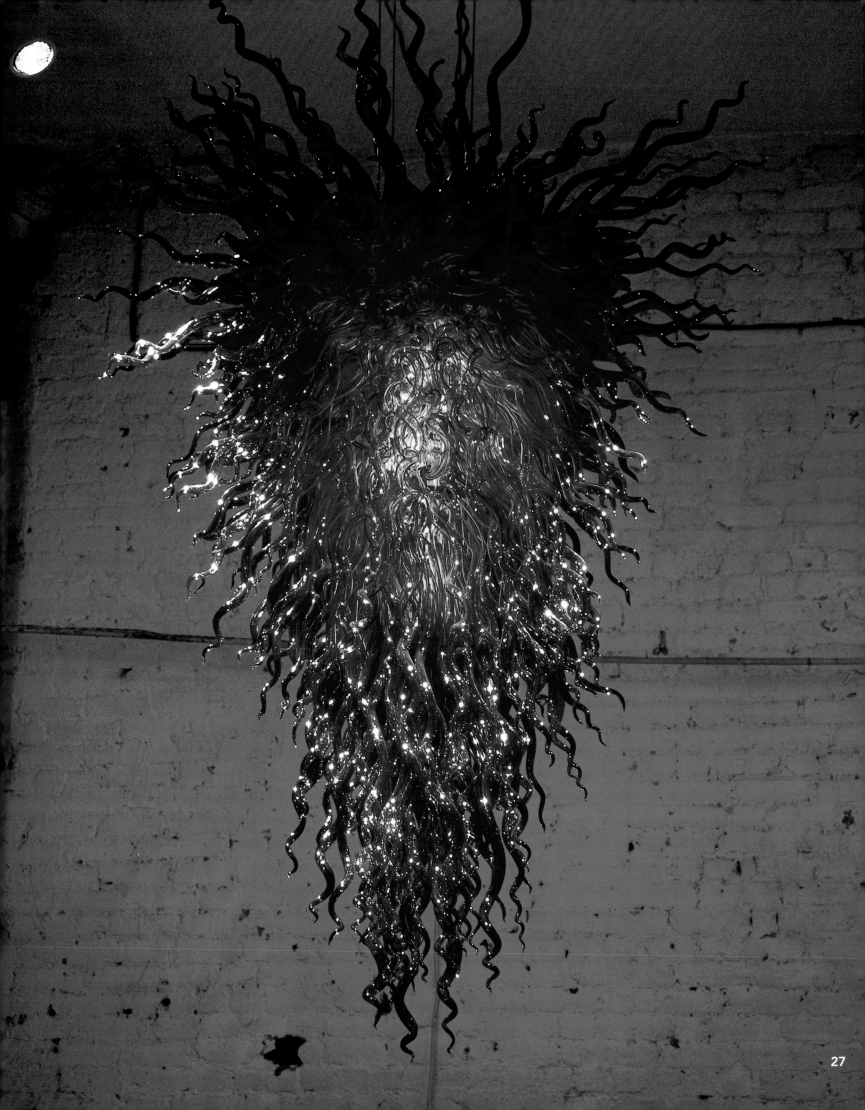

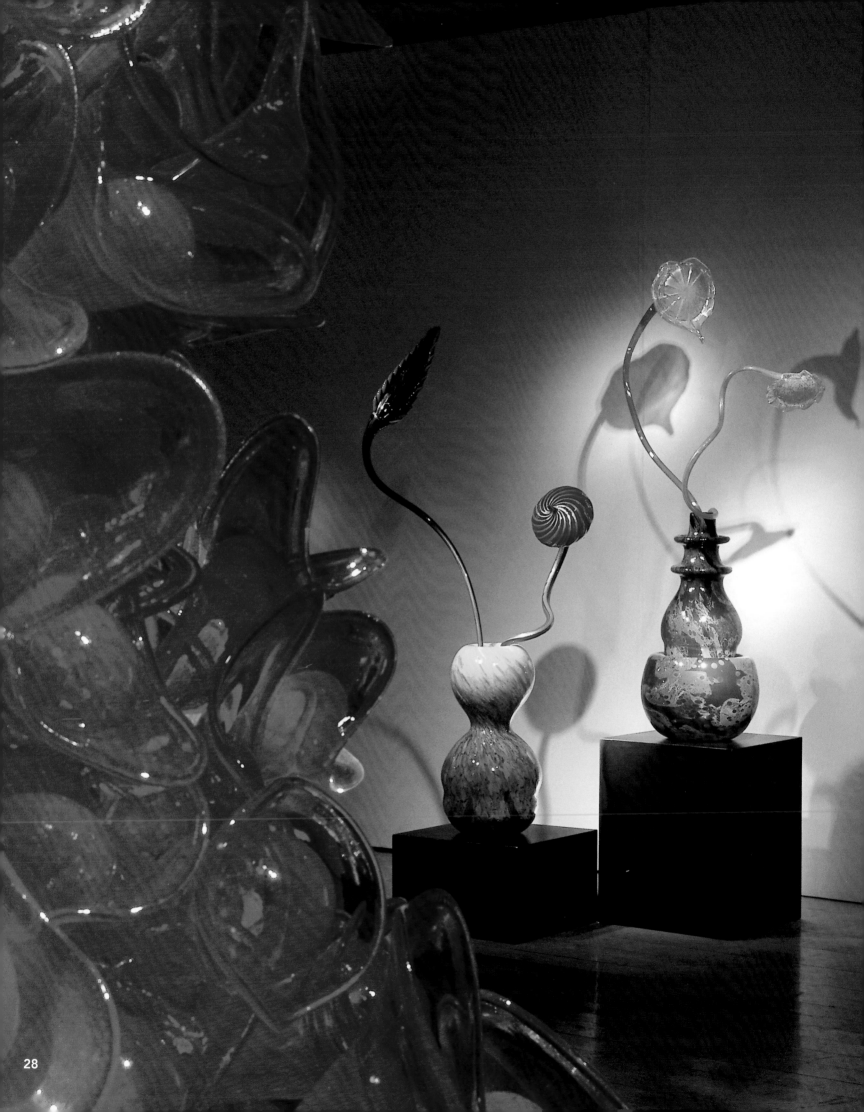

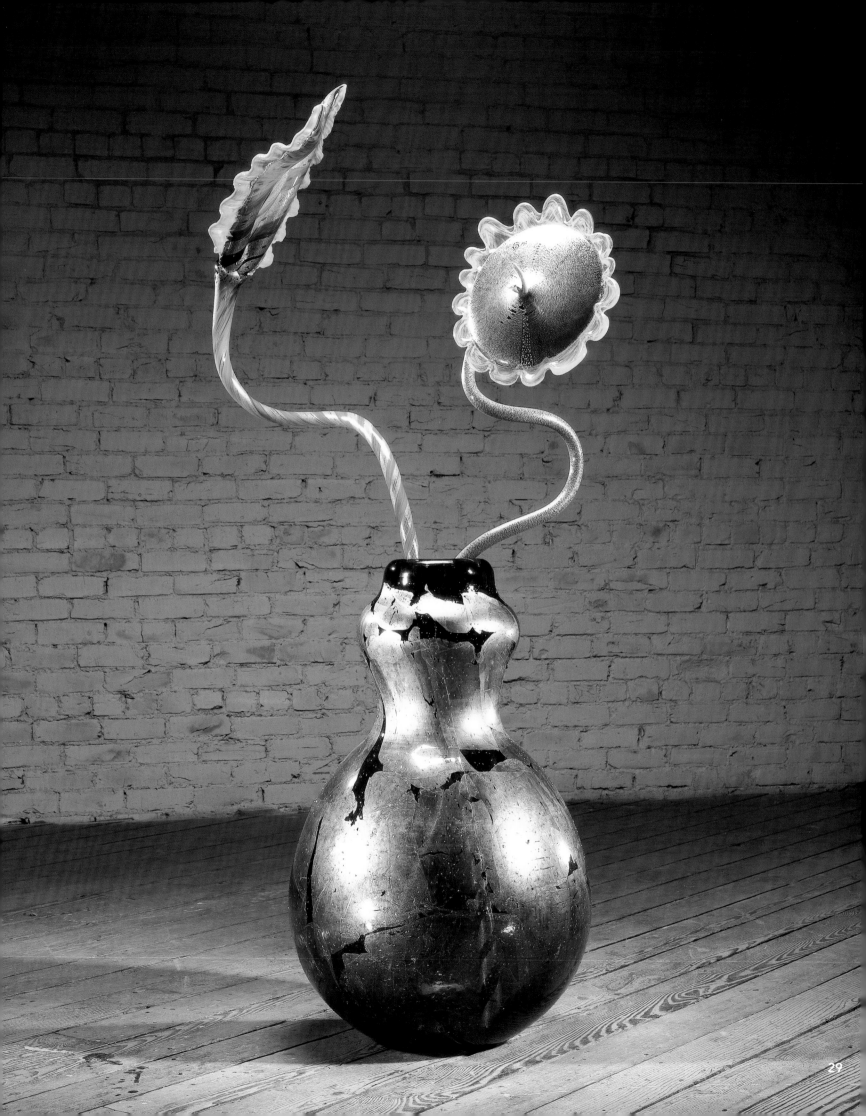

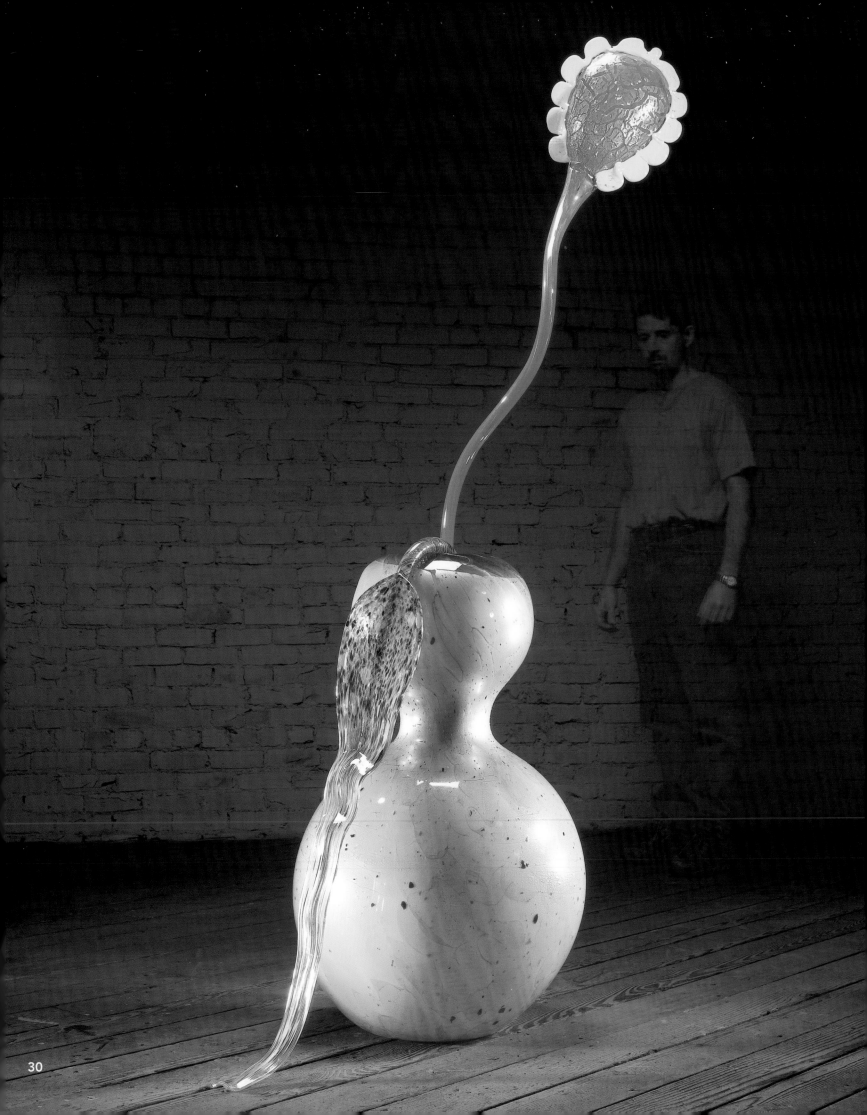

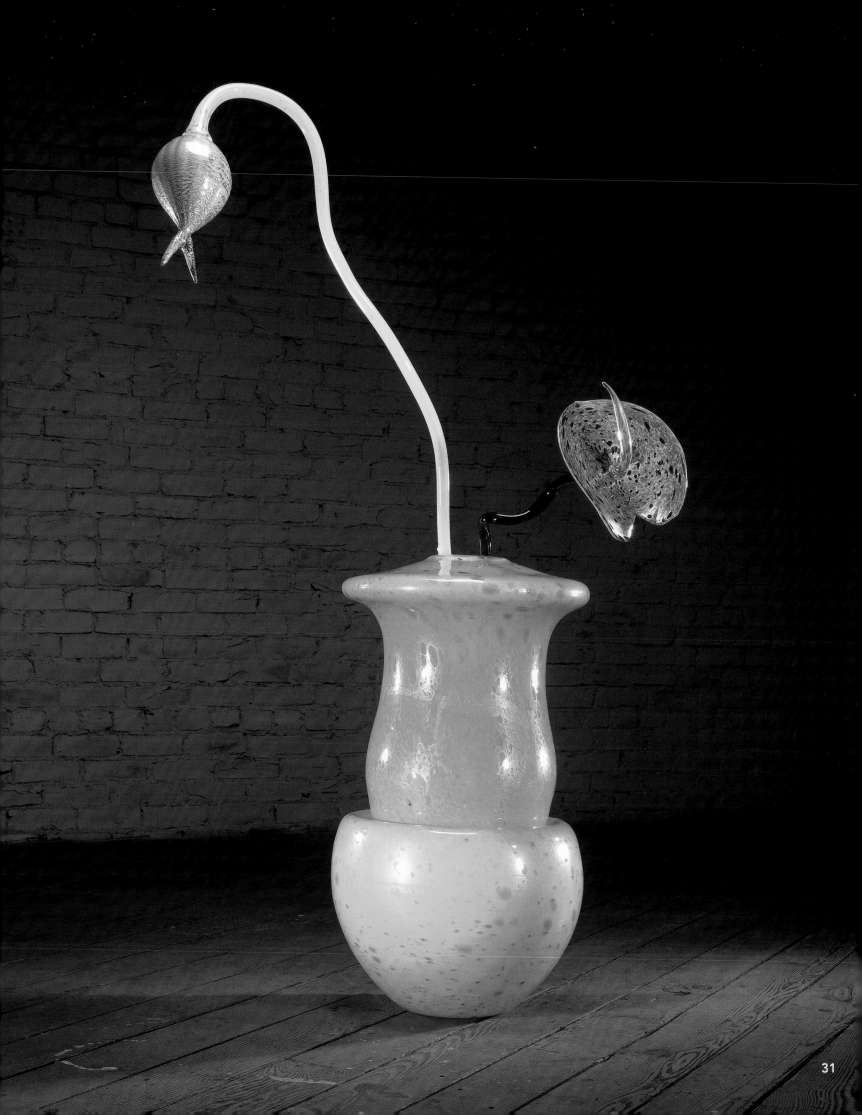

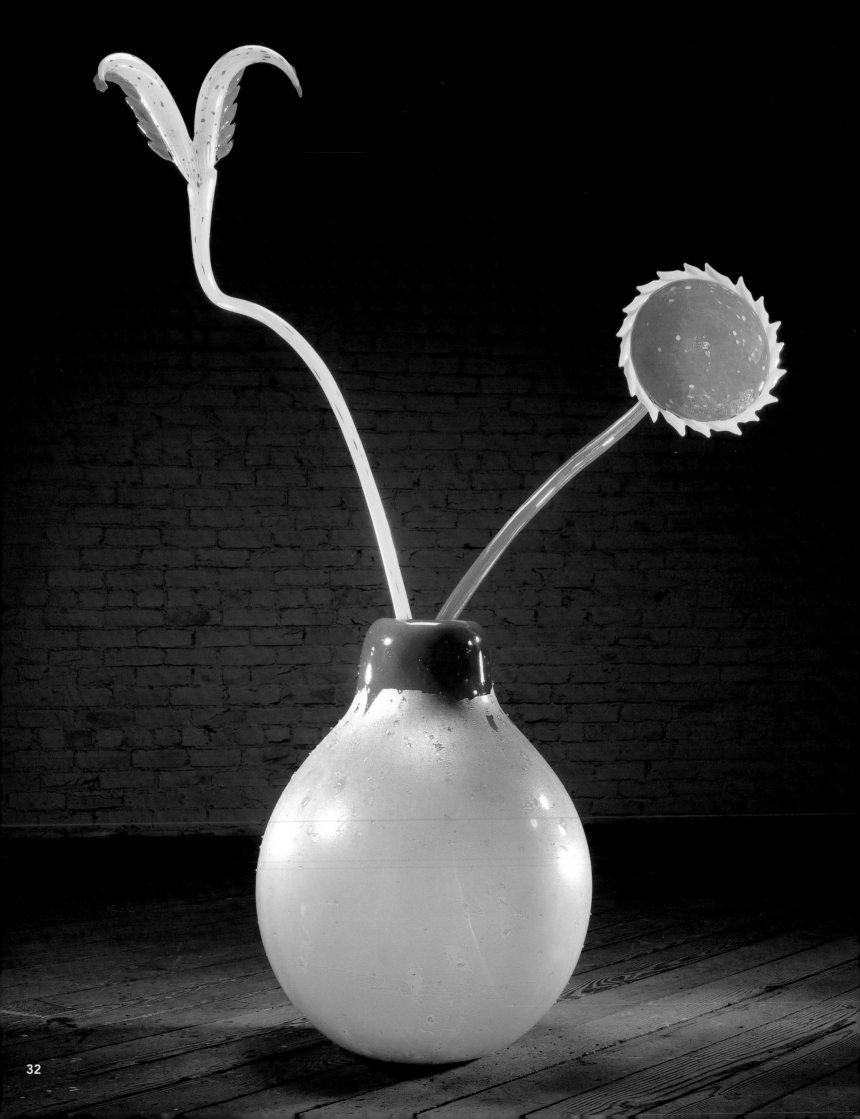

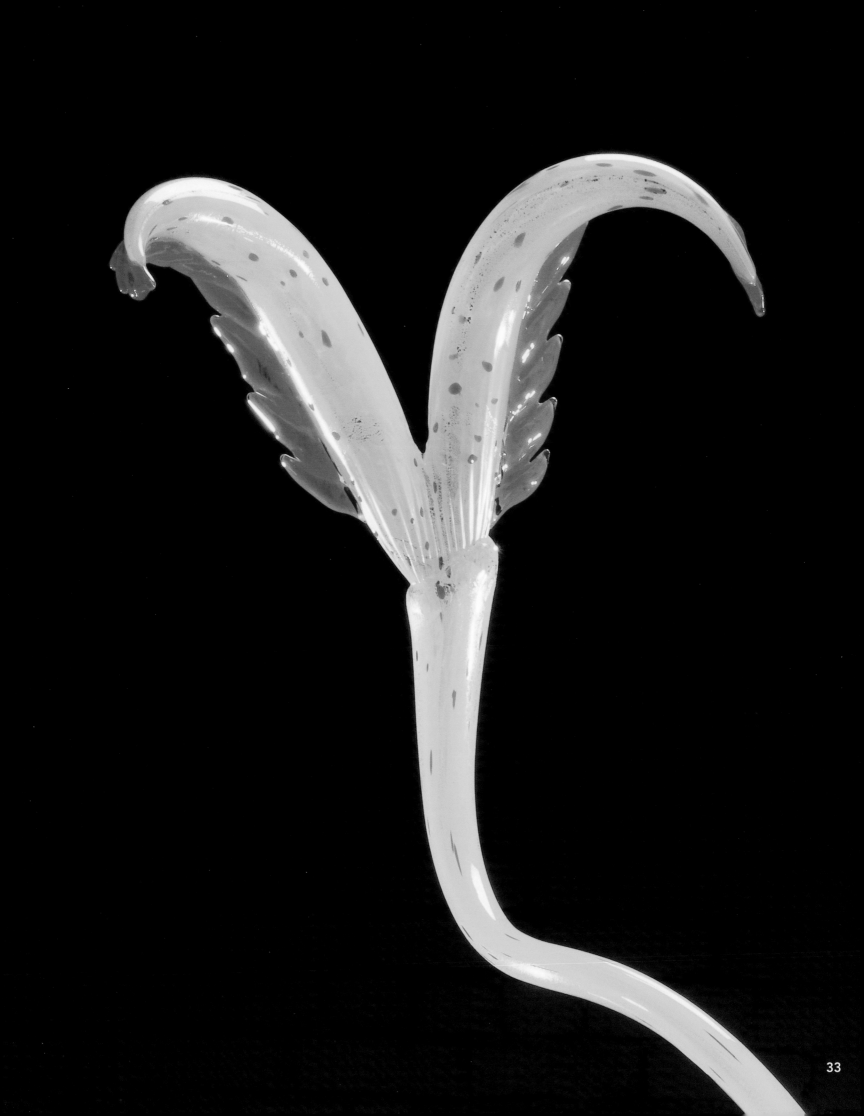

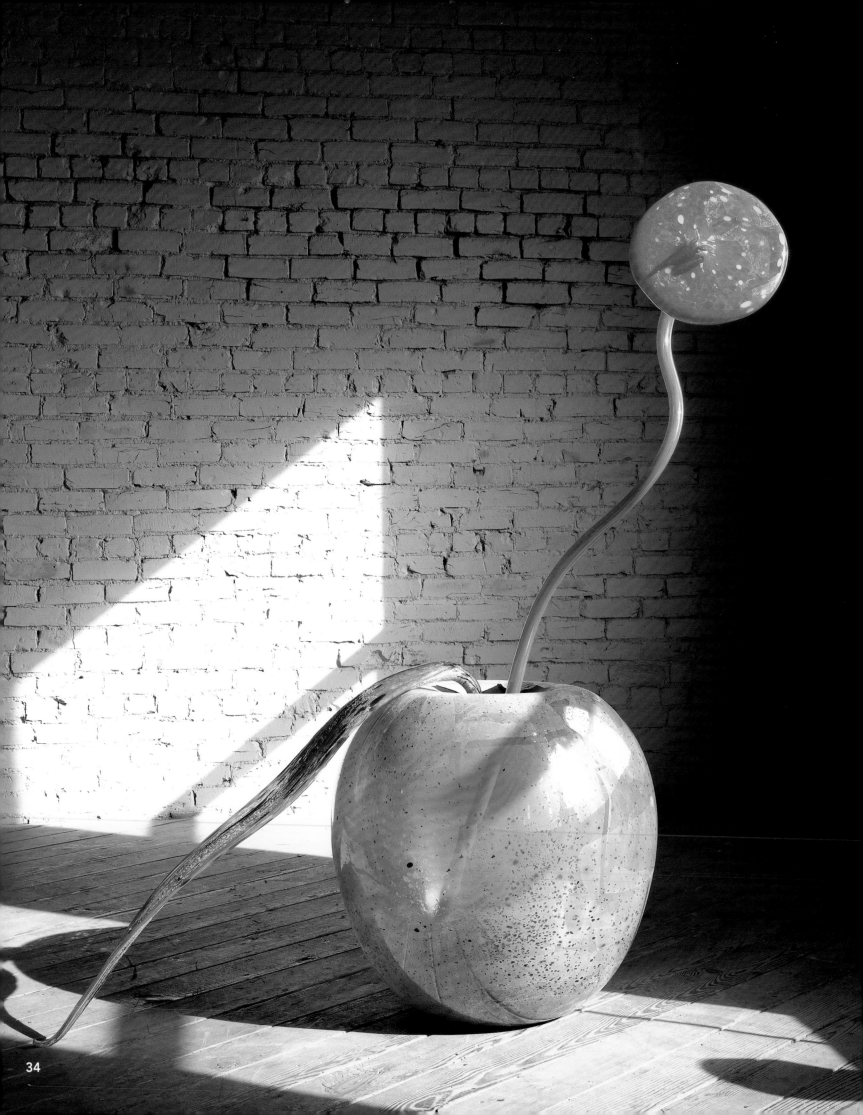

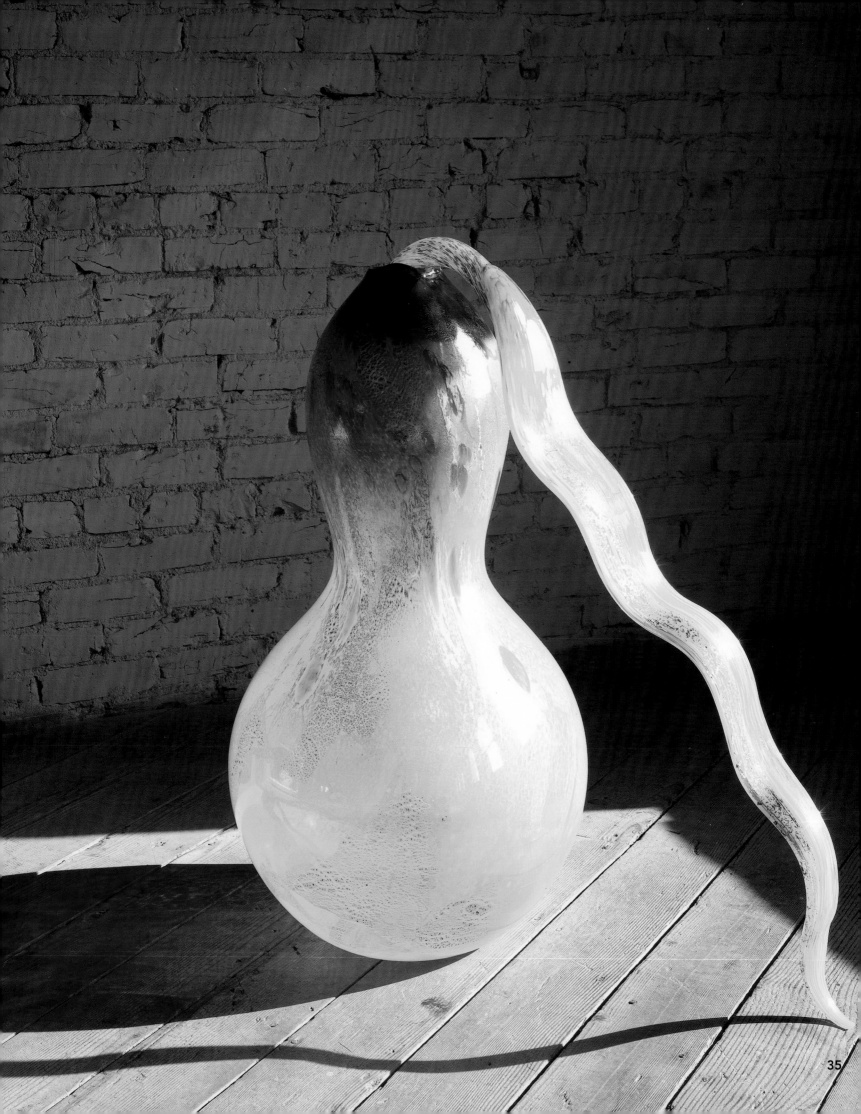

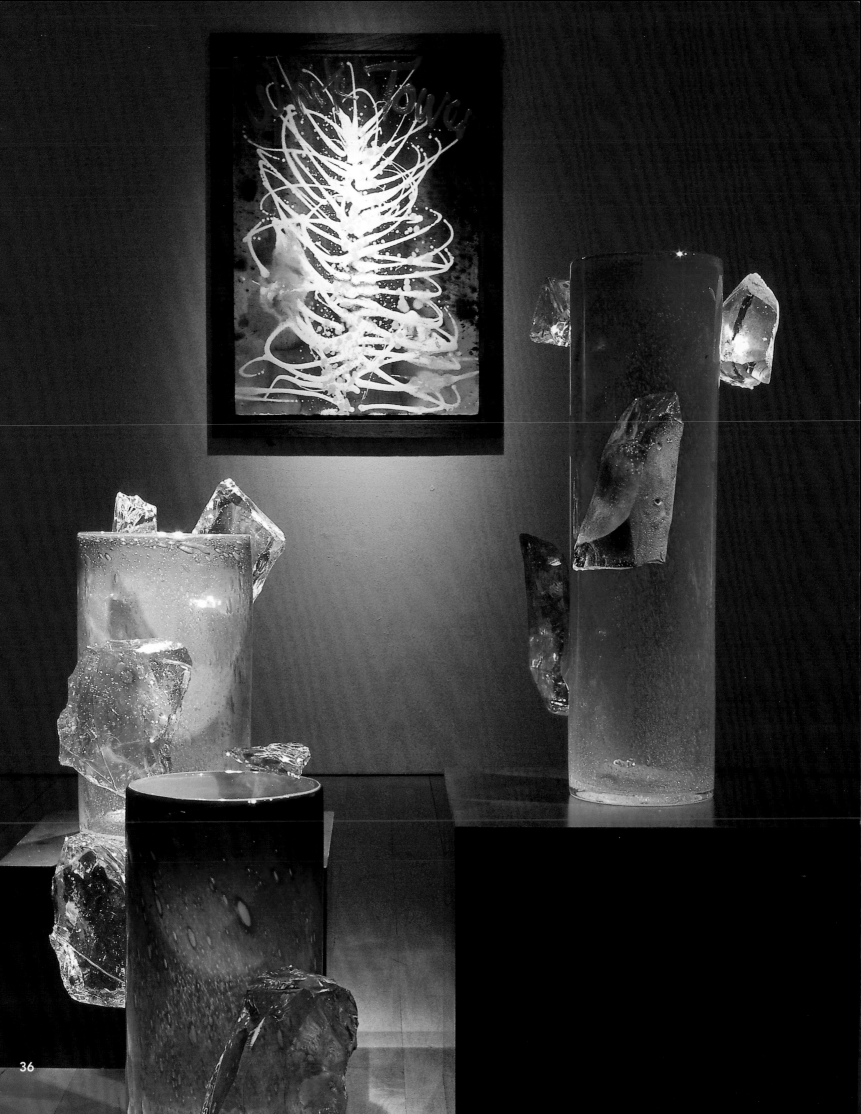

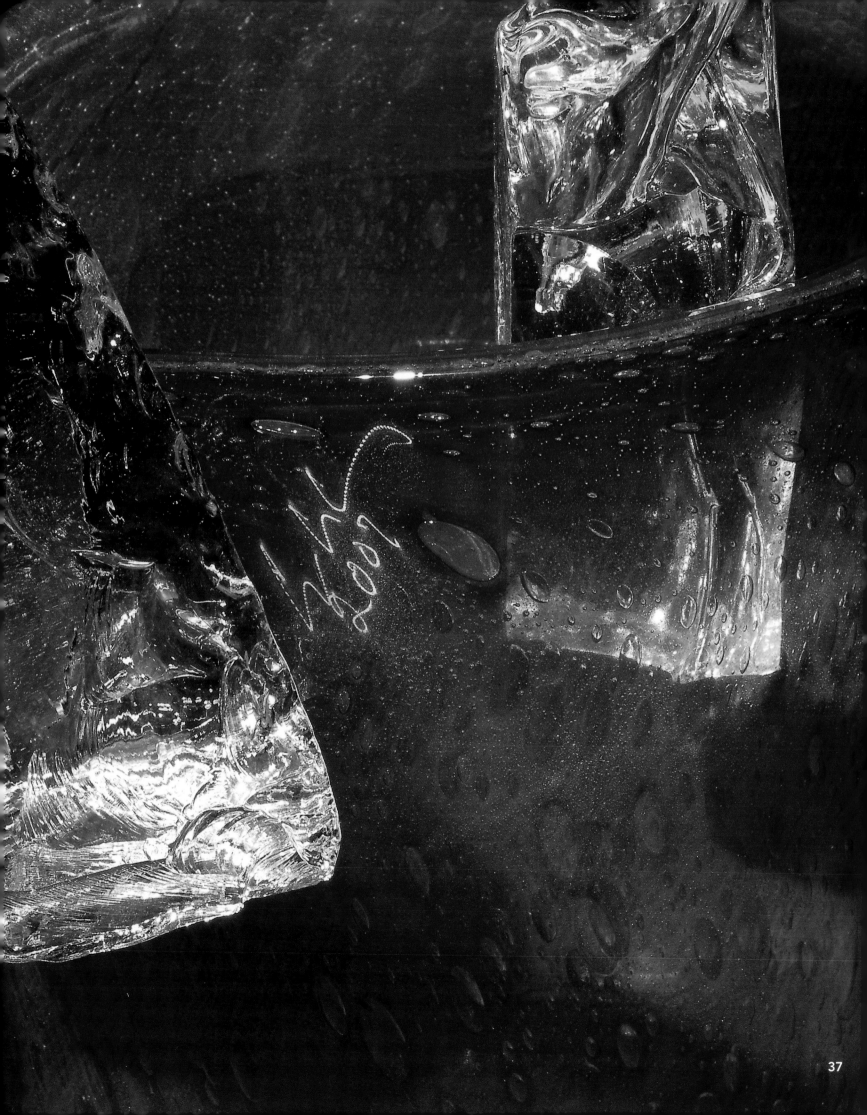

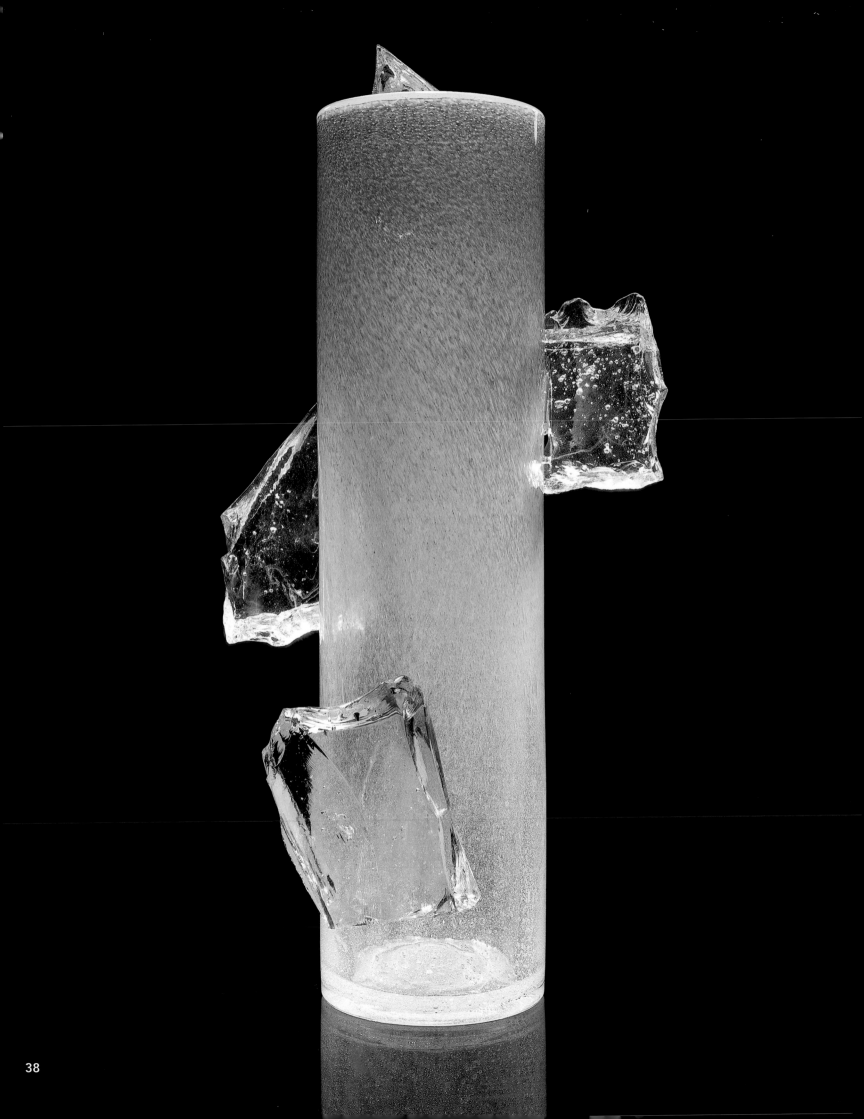

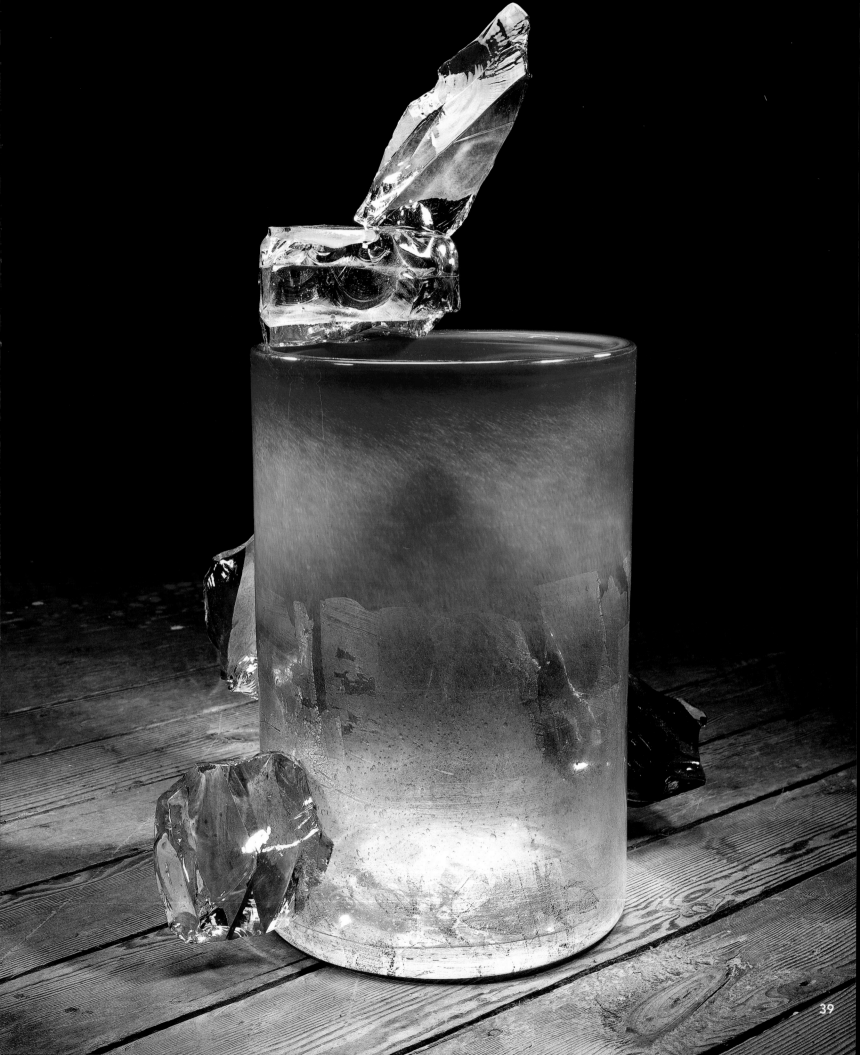

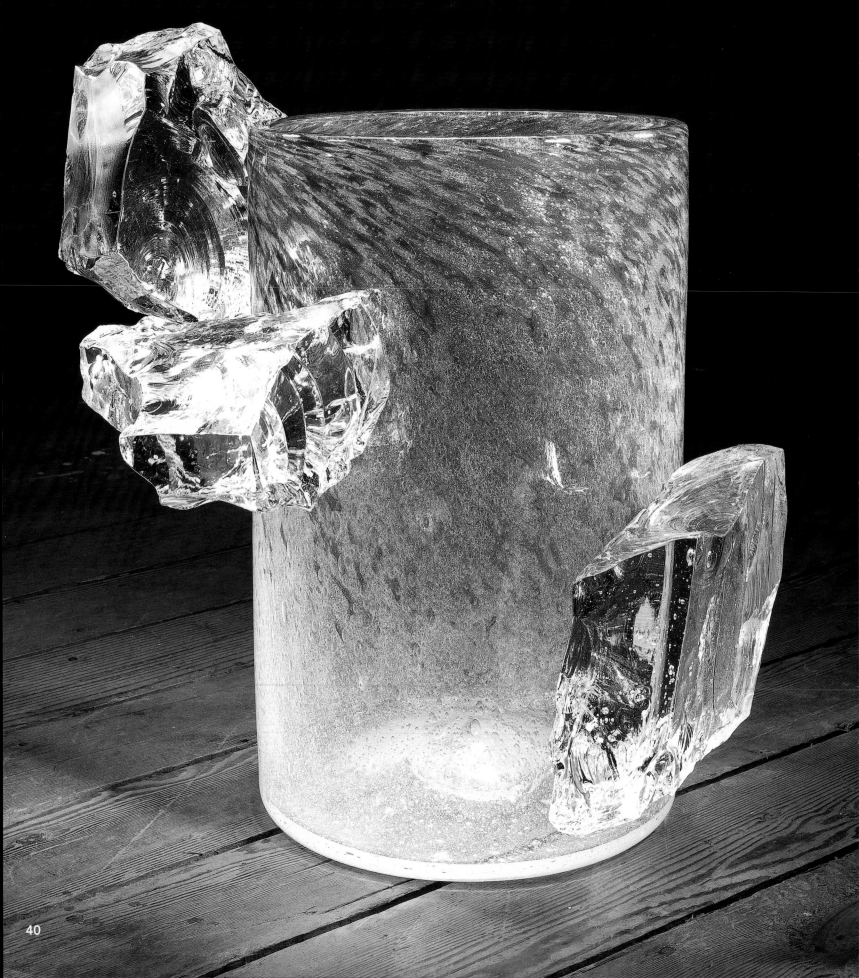

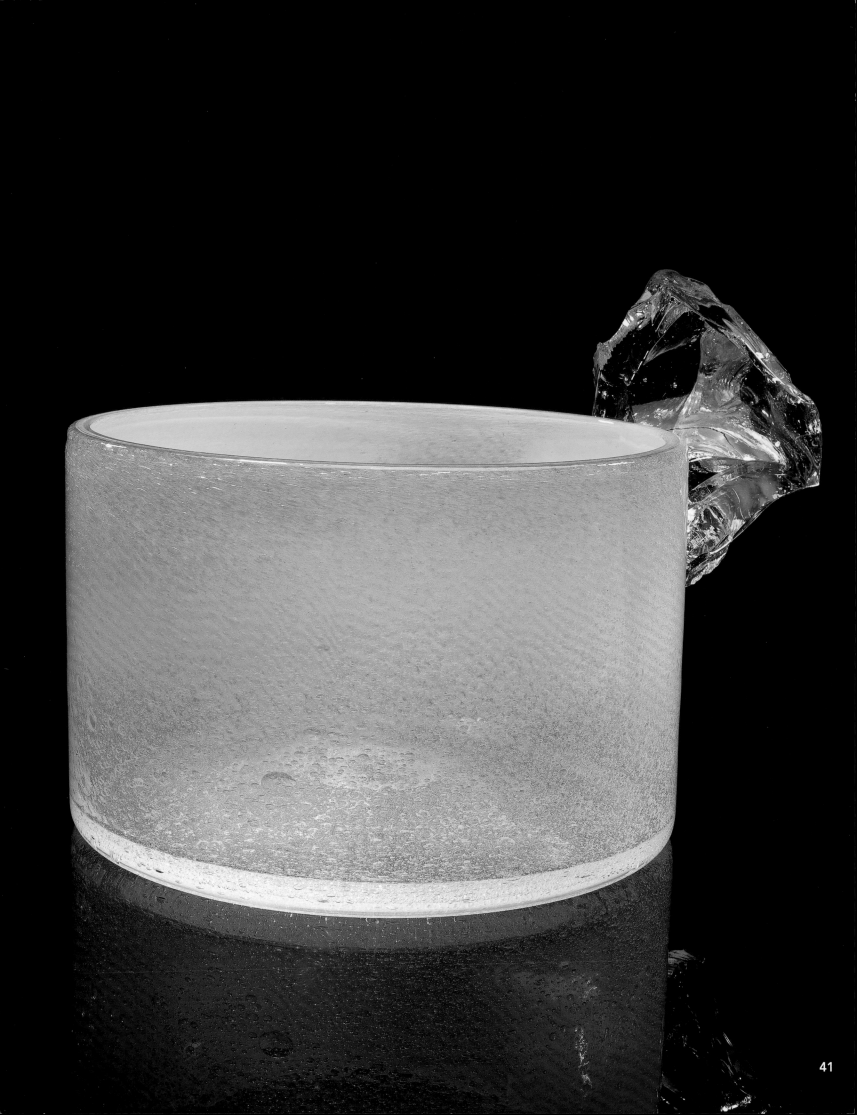

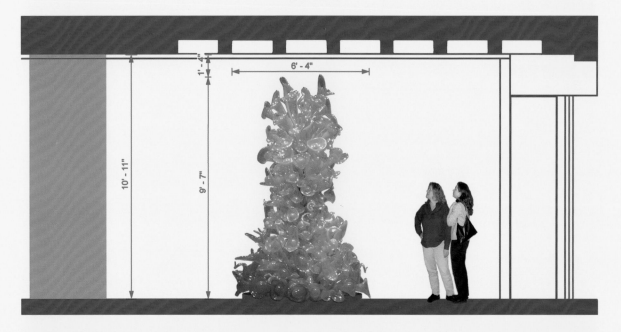

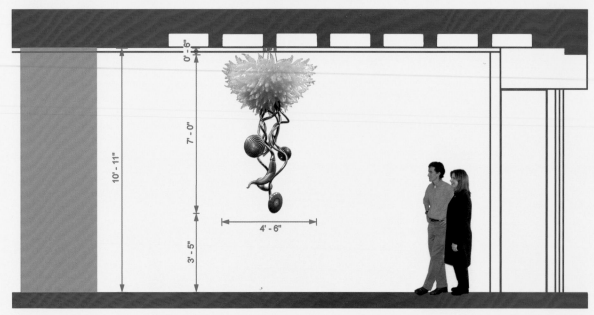

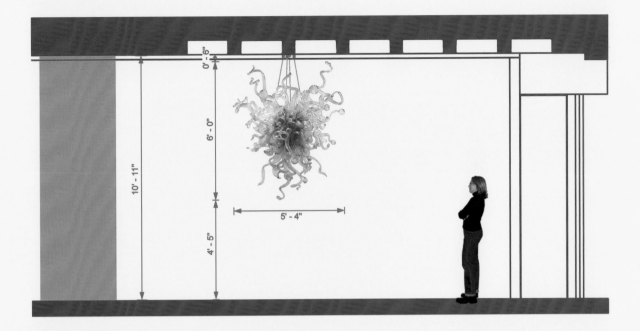

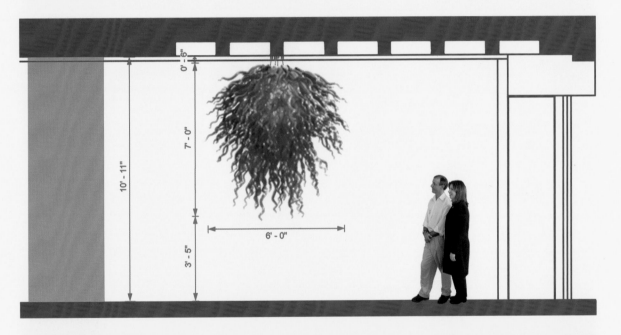

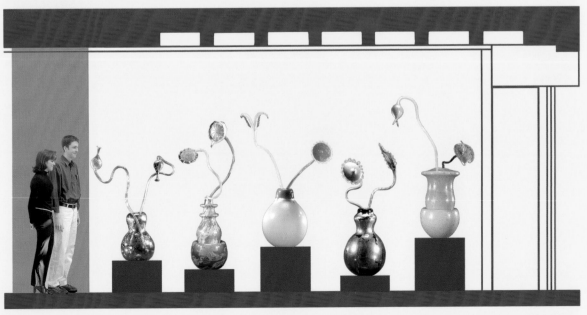

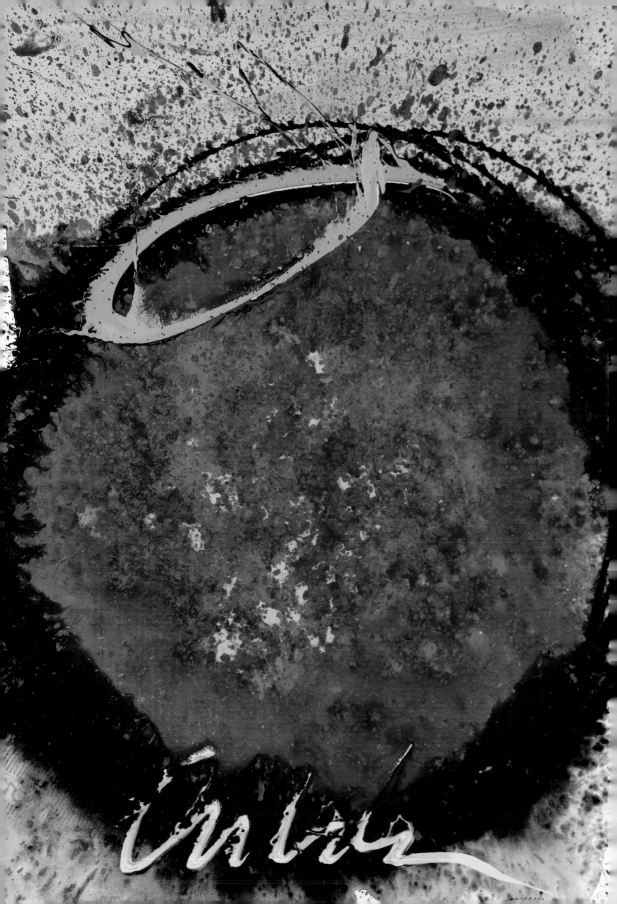

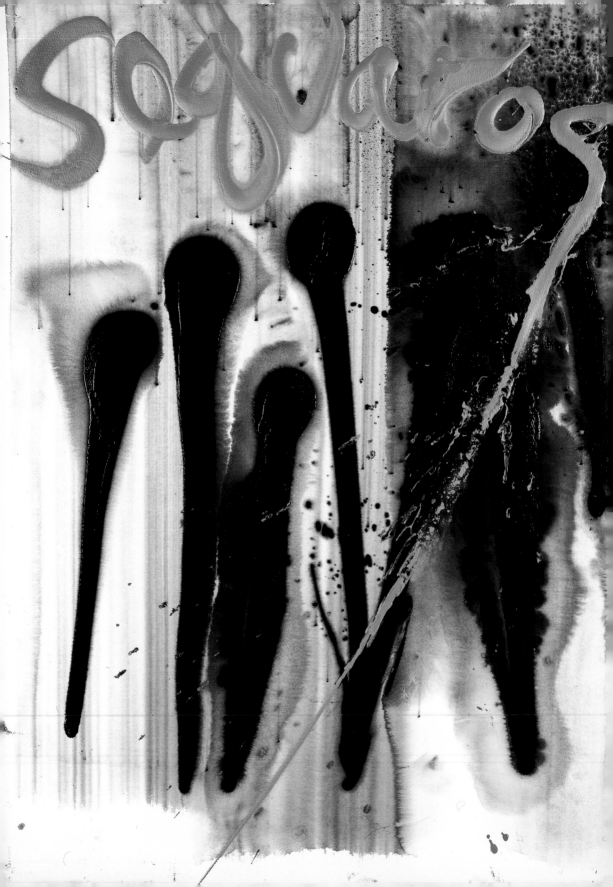

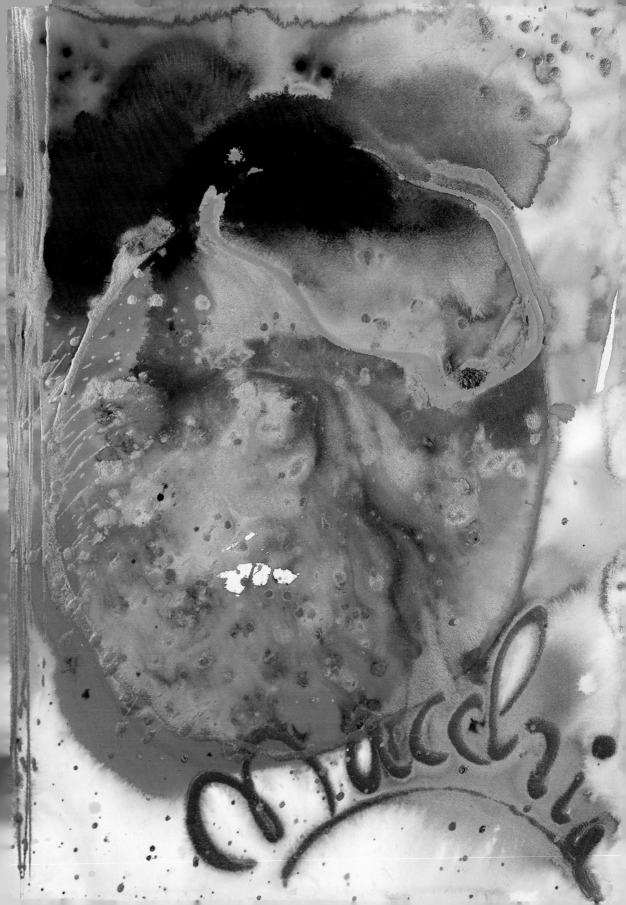

Installations On Site

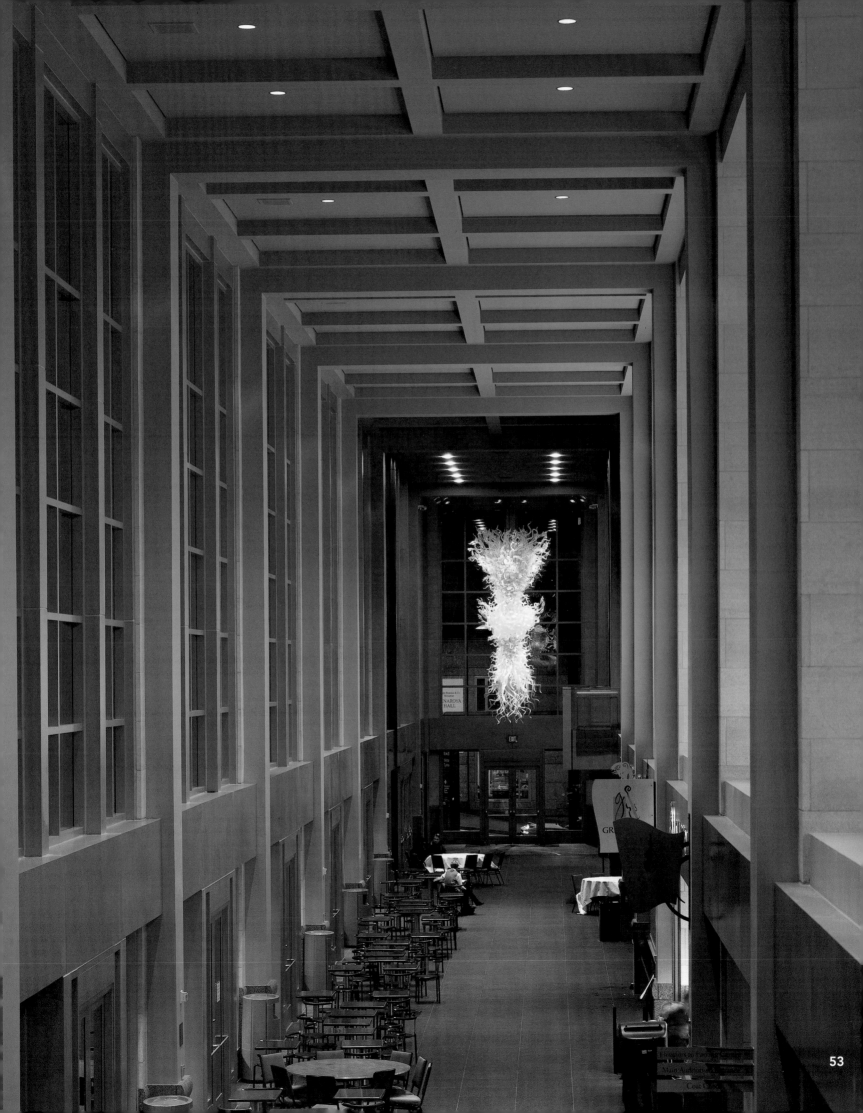

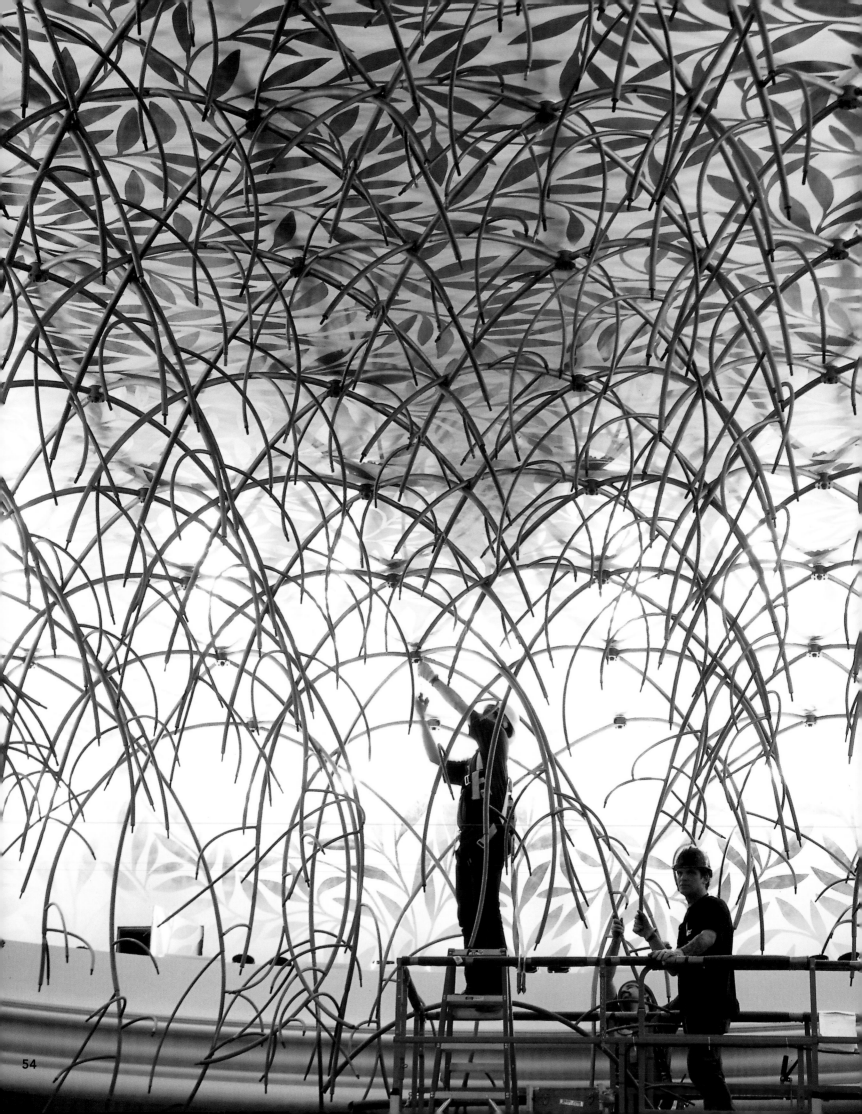

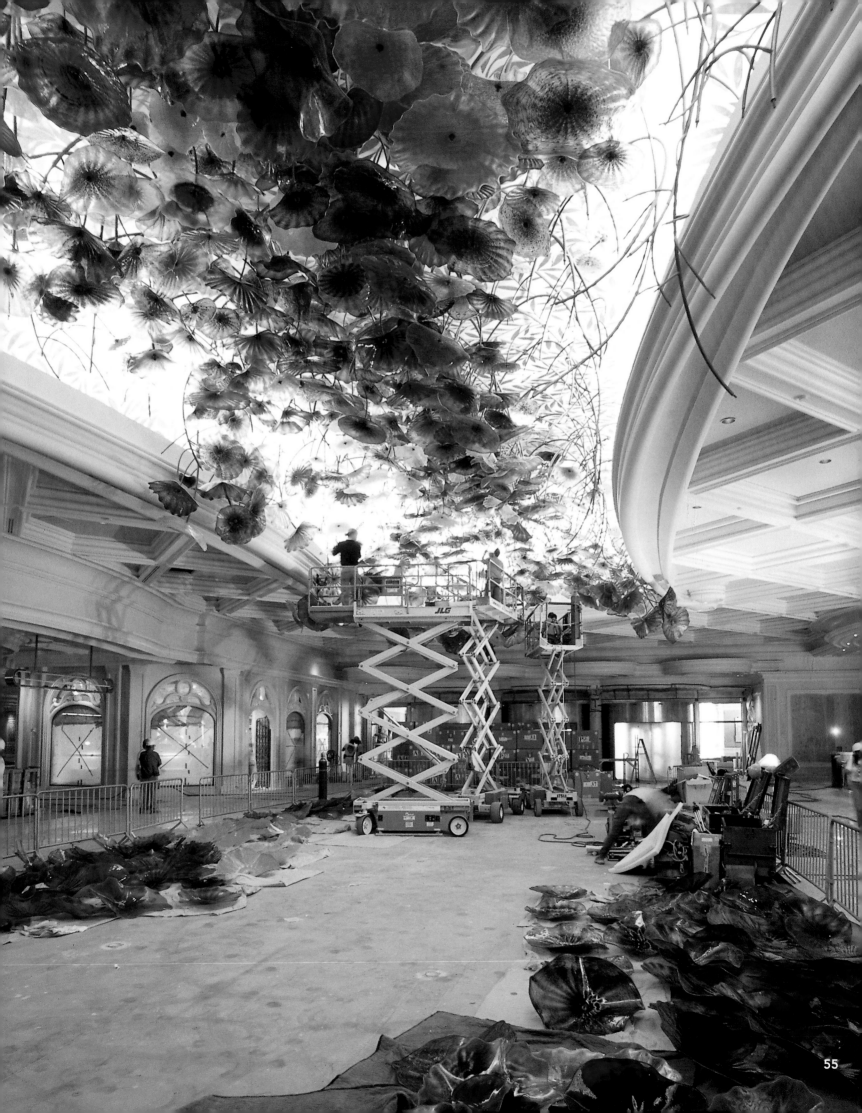

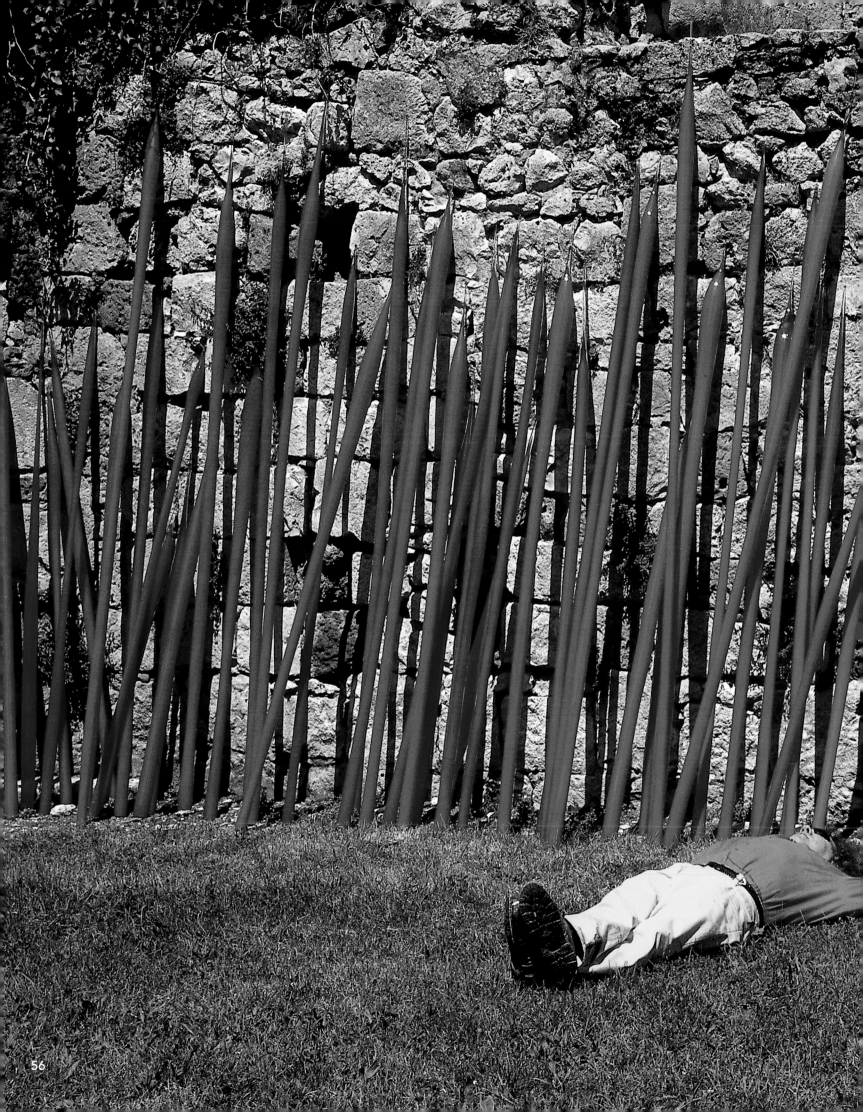

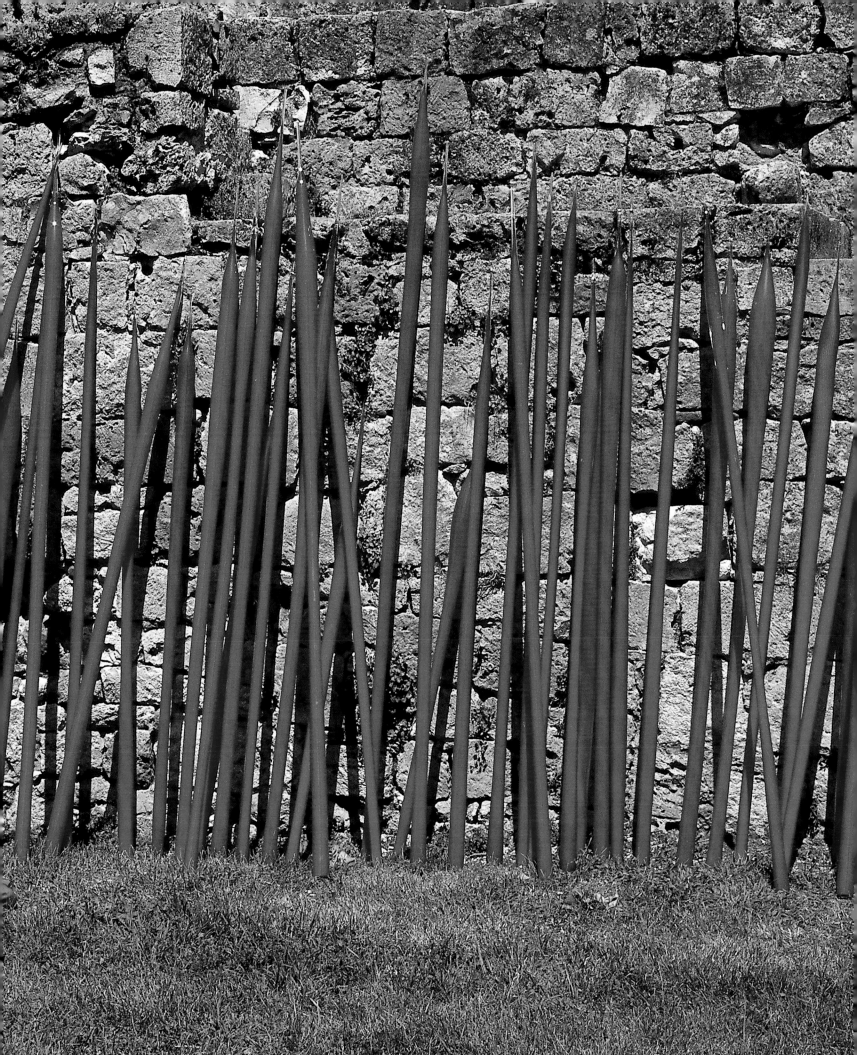

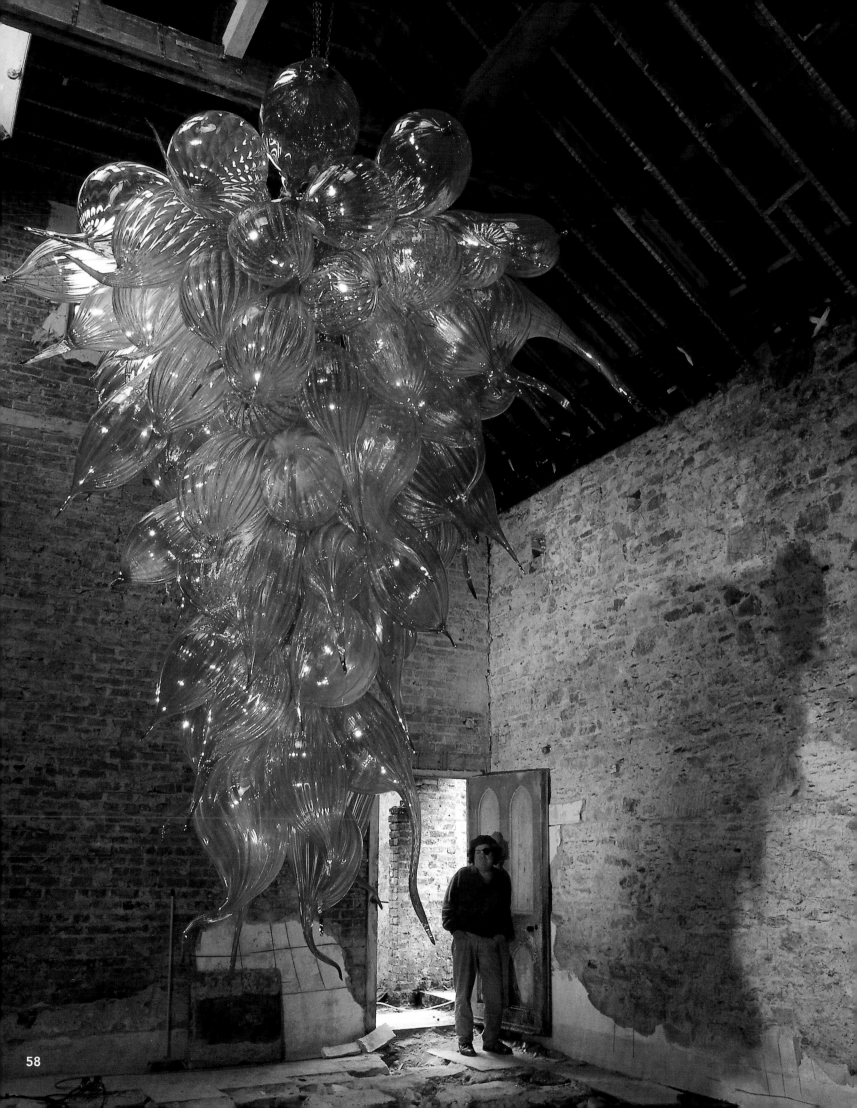

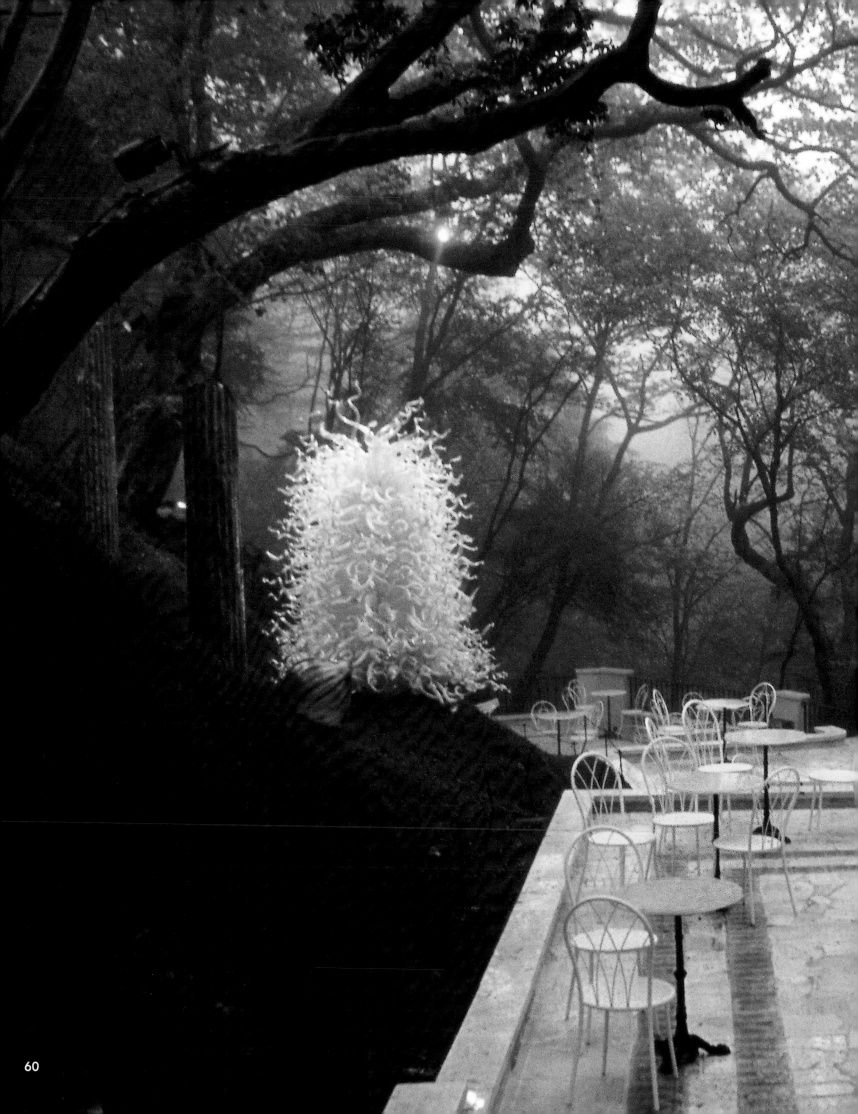

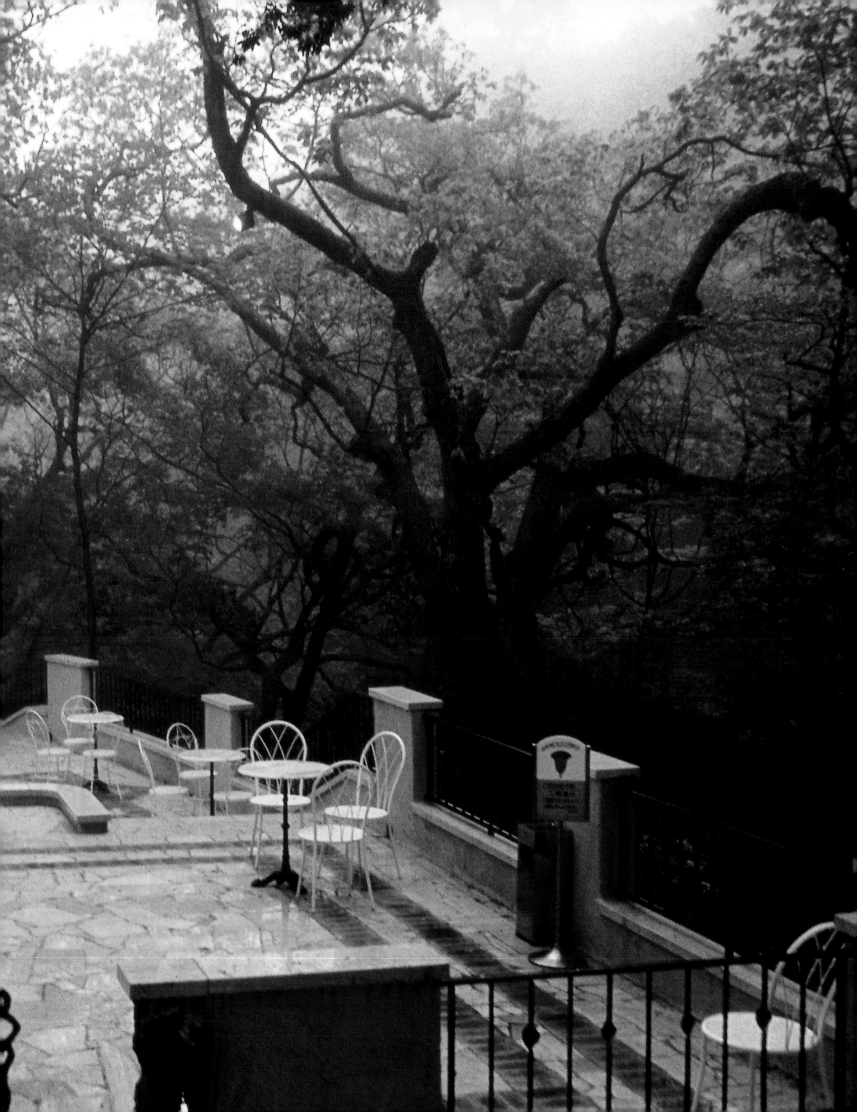

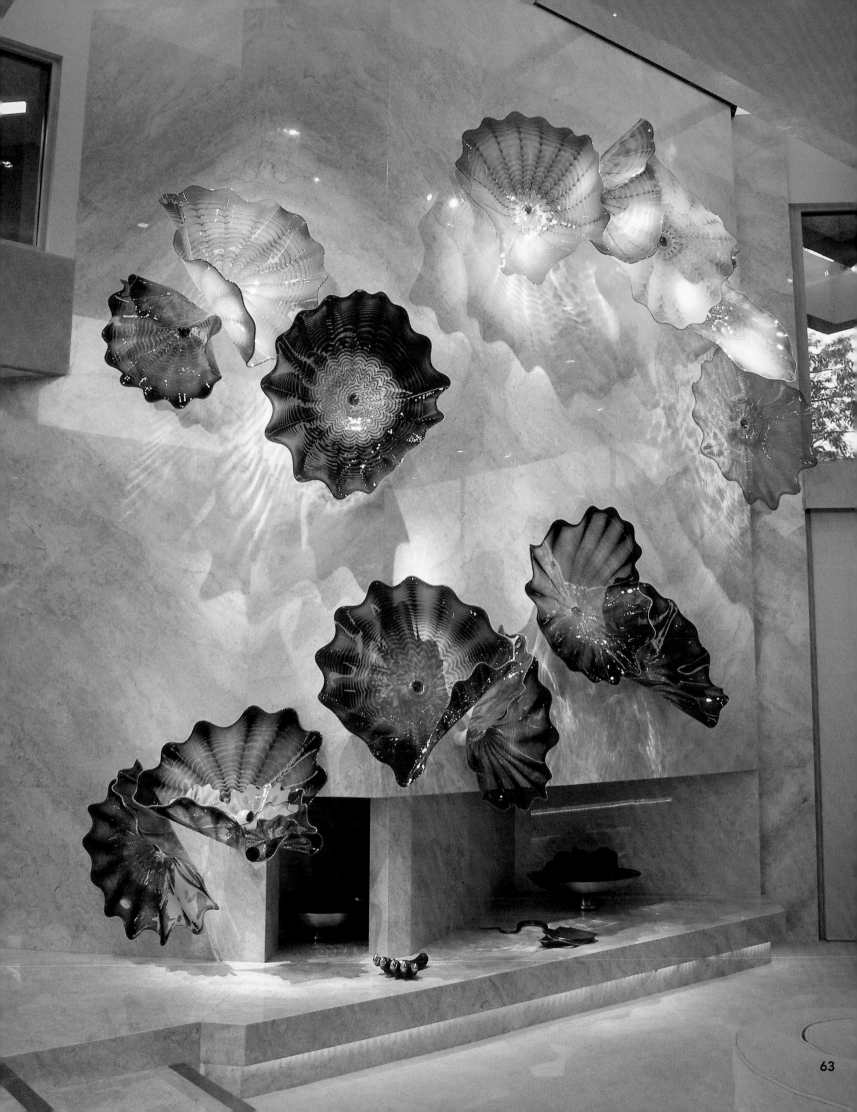

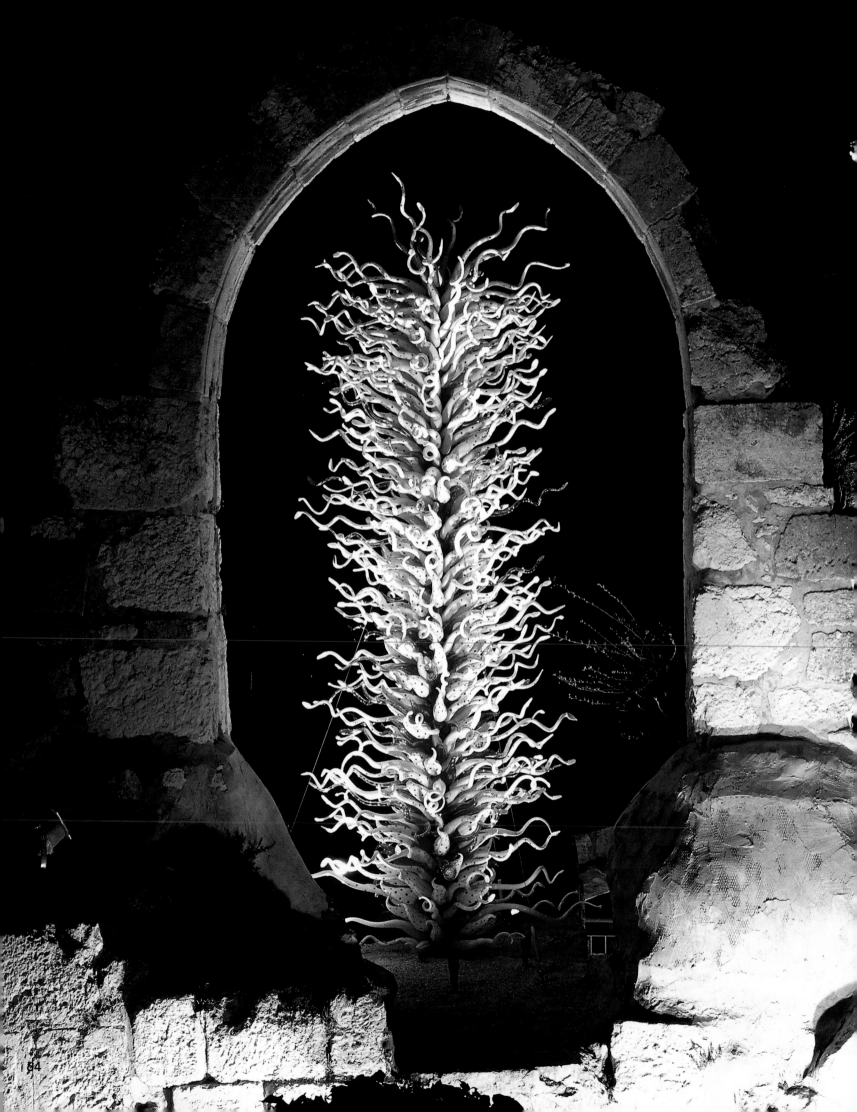

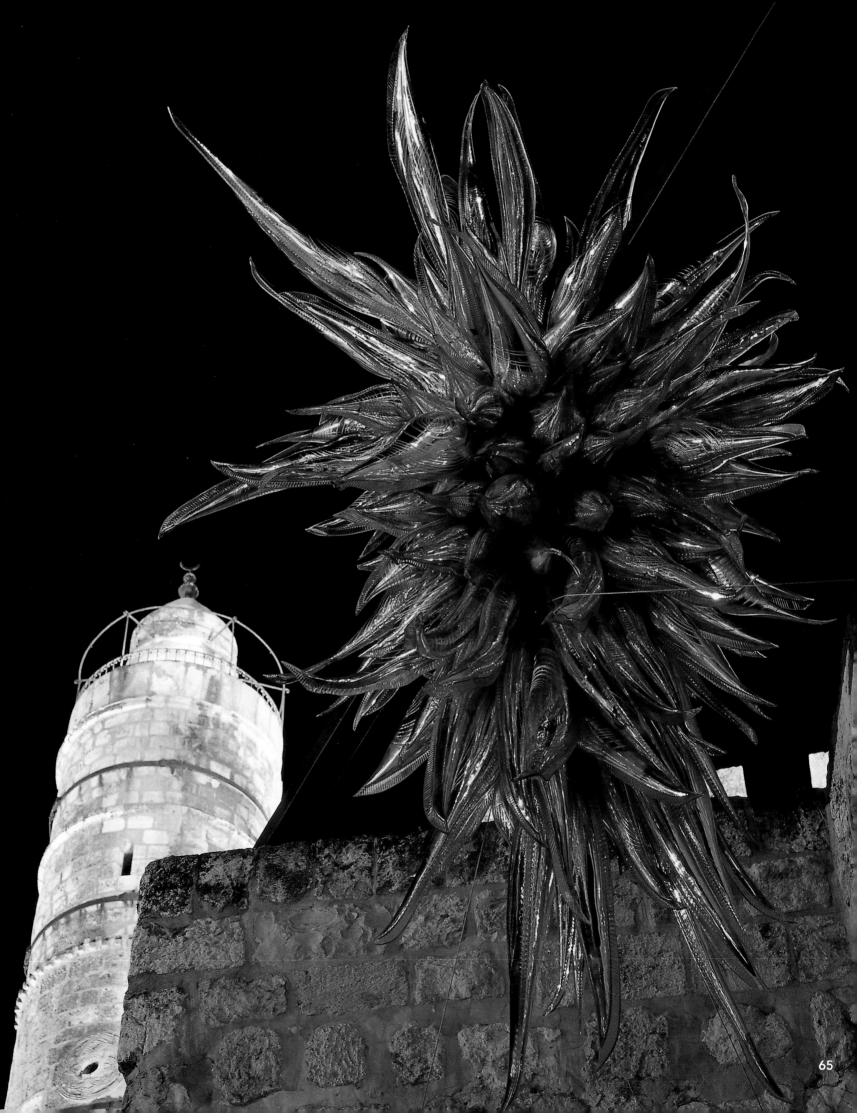

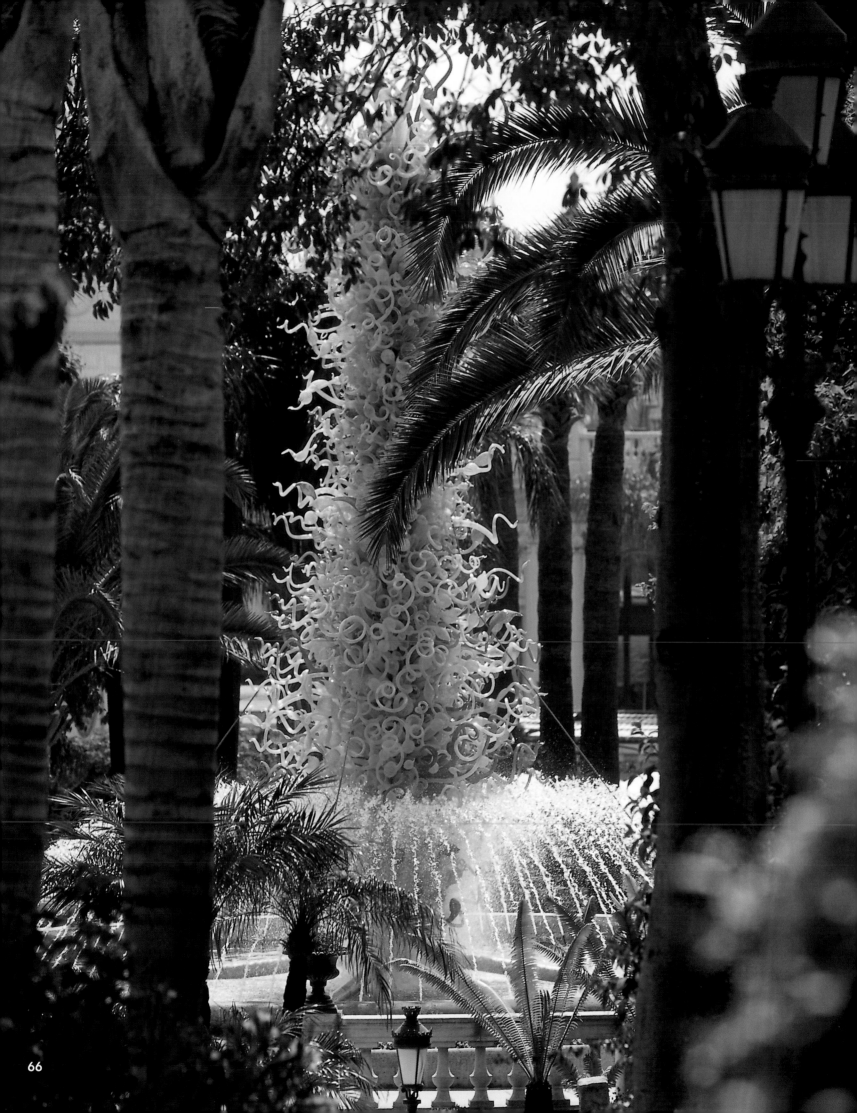

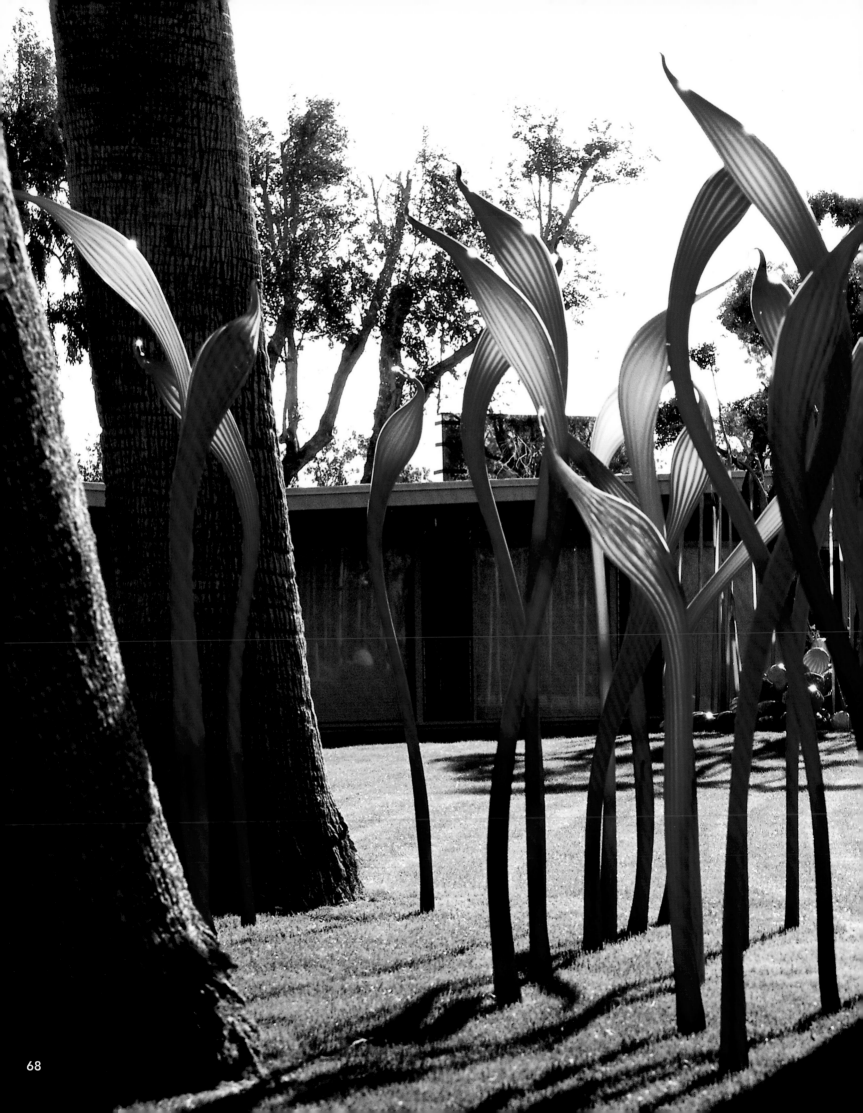

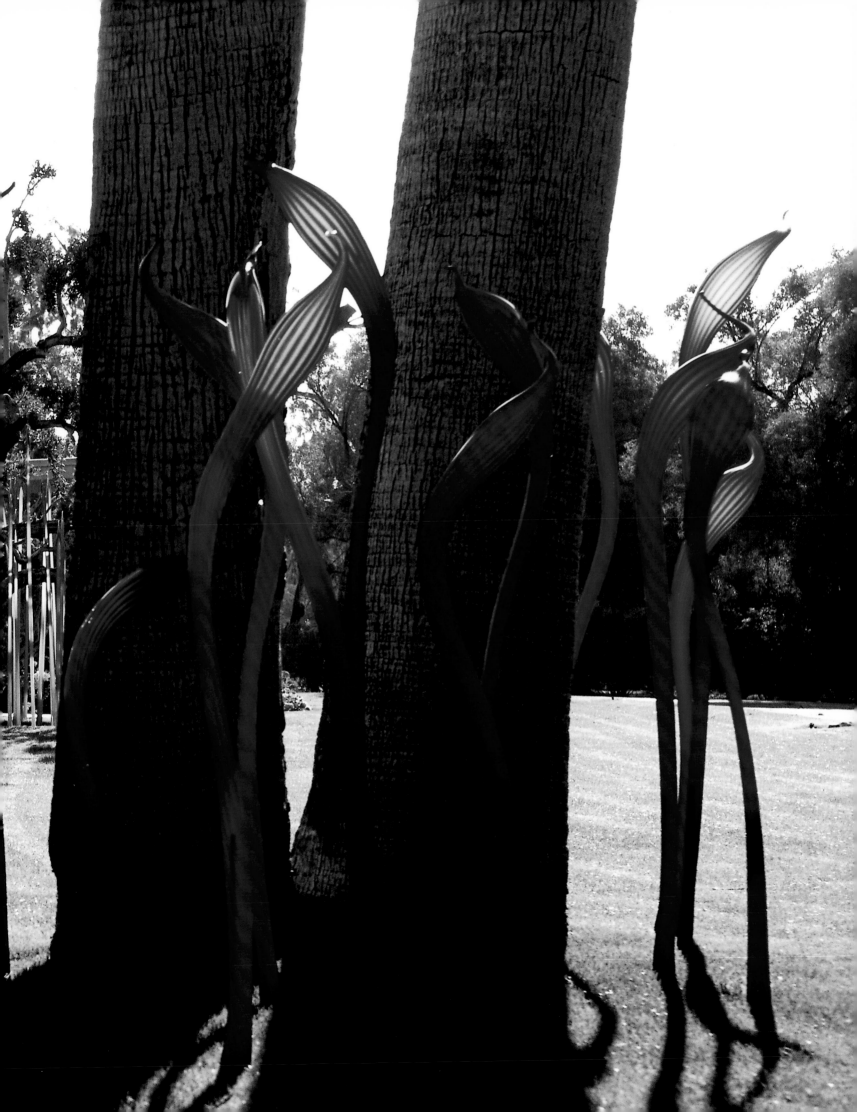

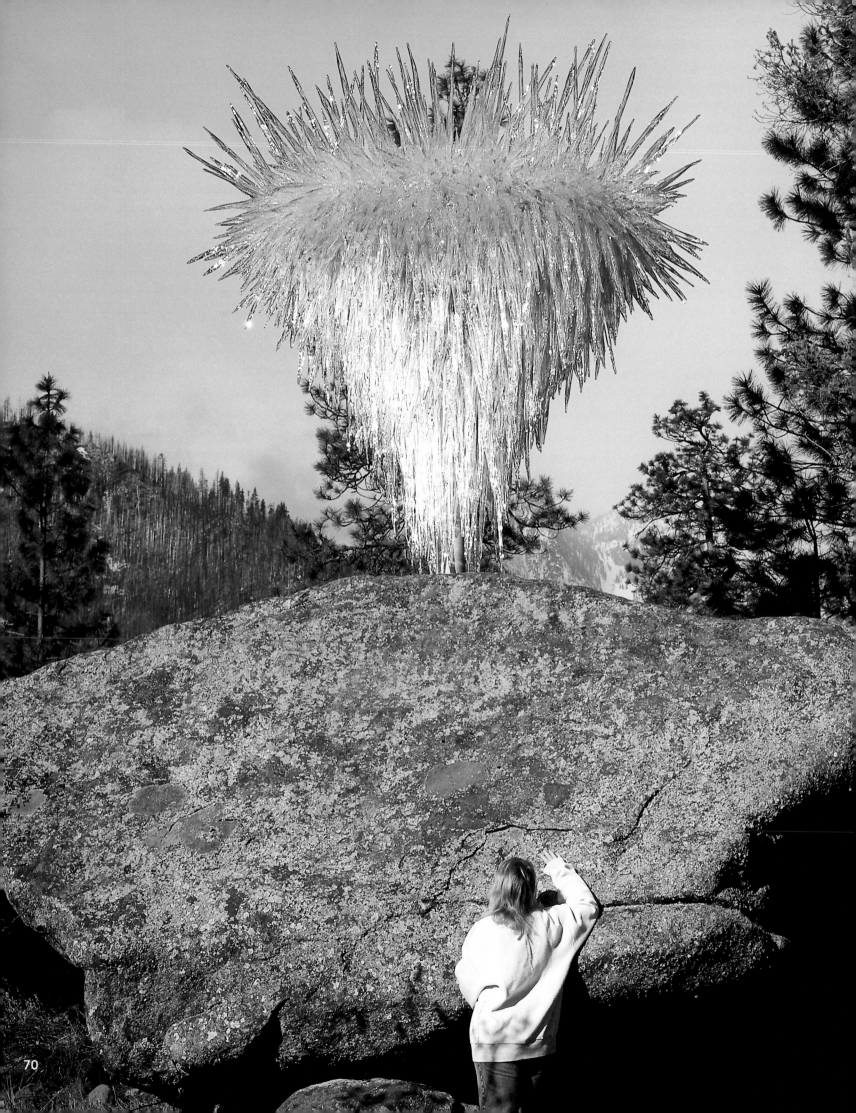

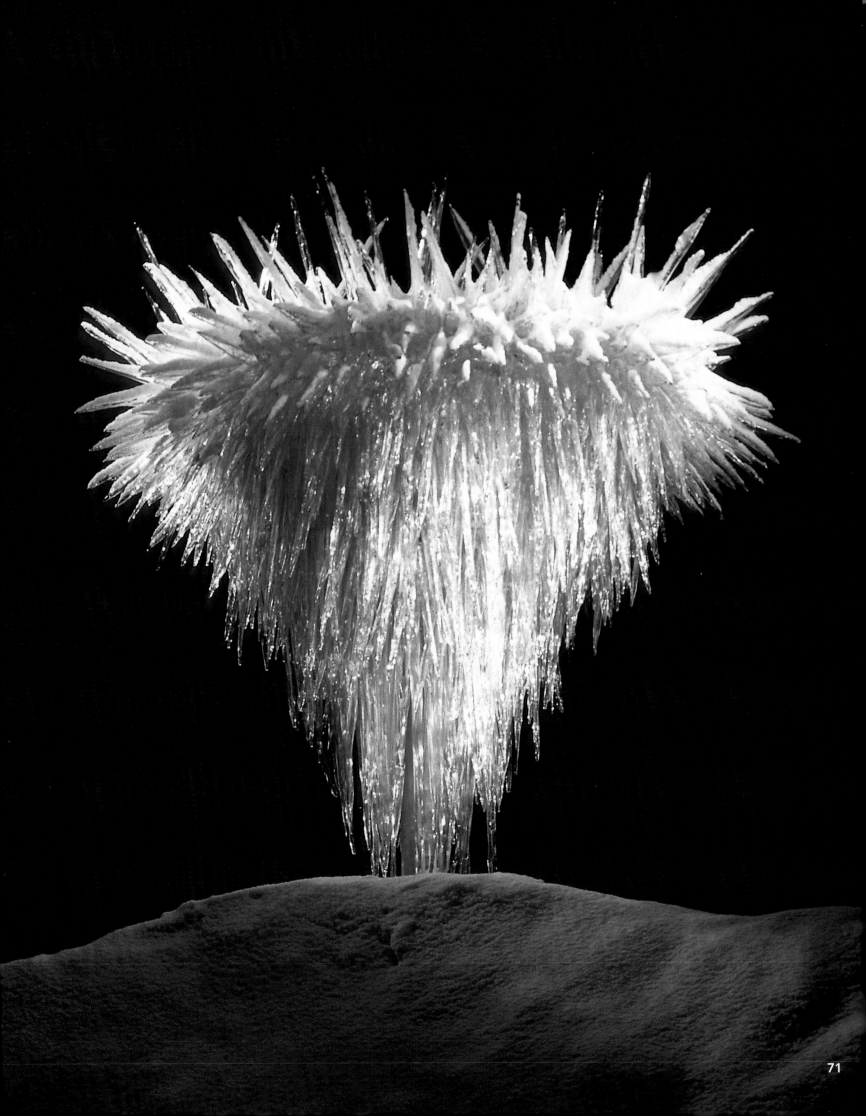

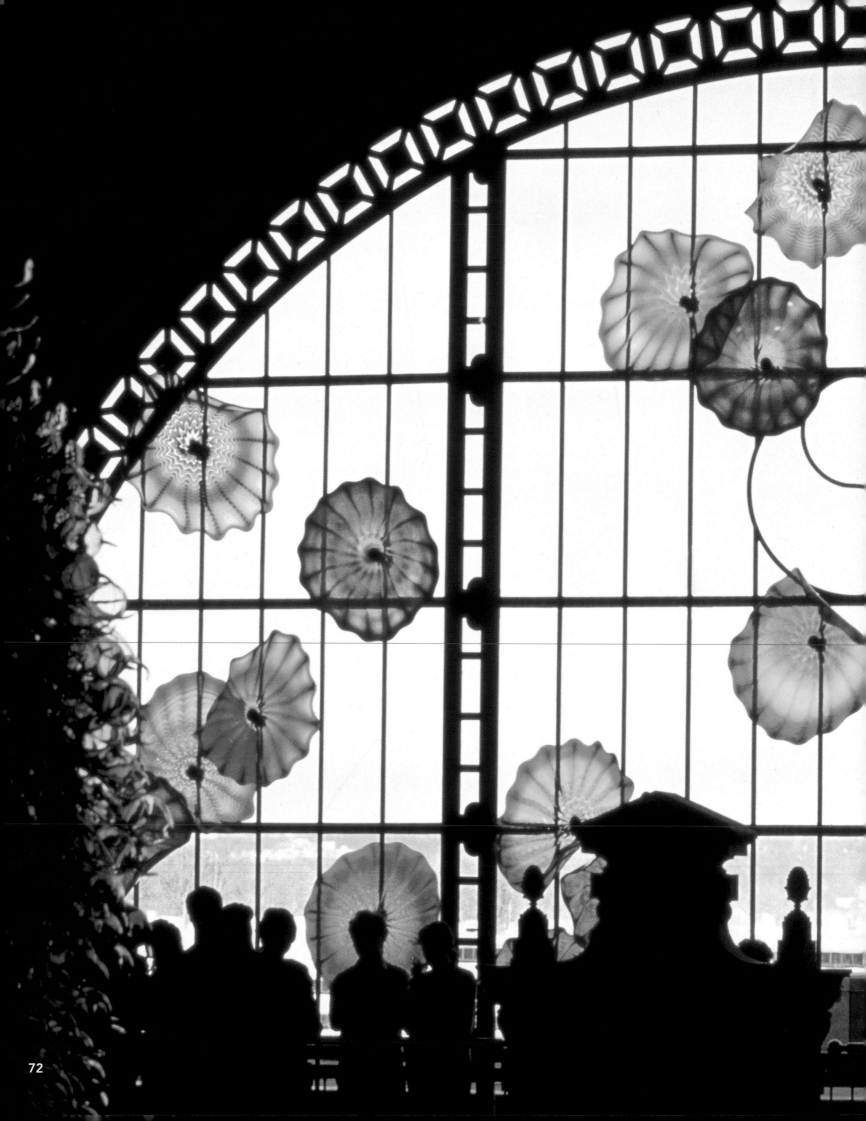

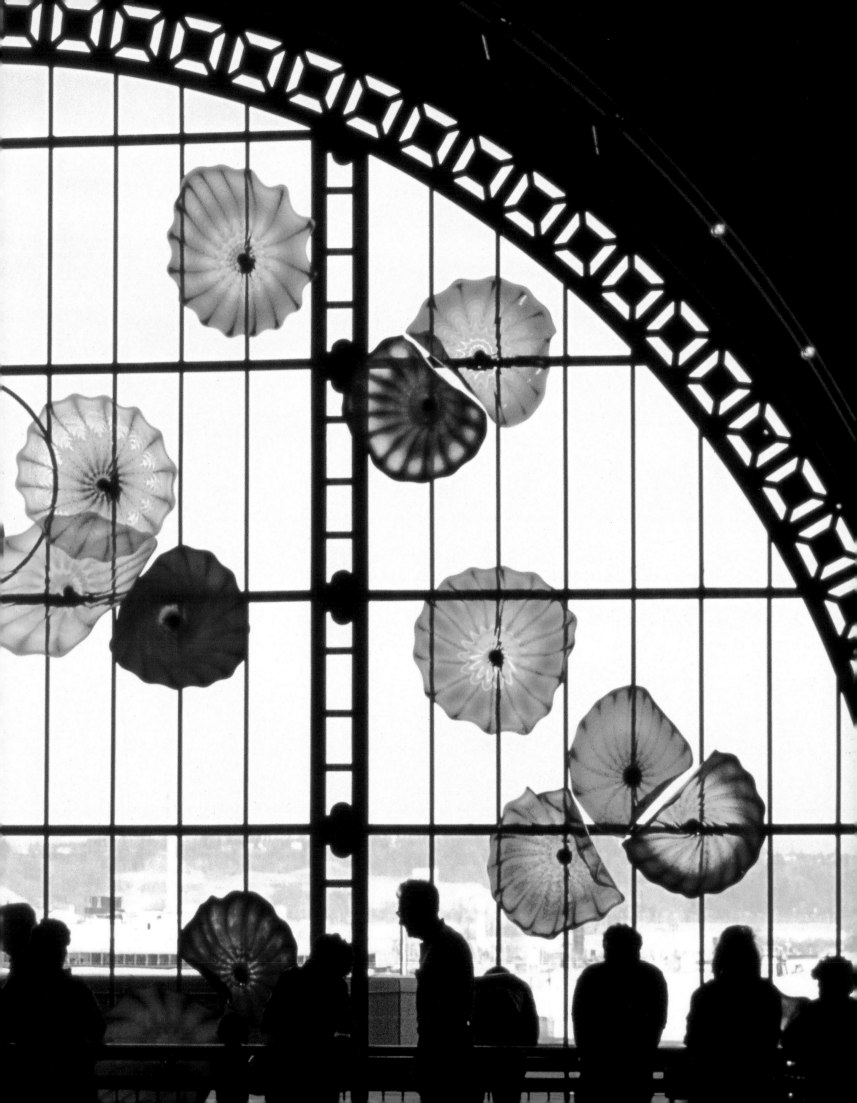

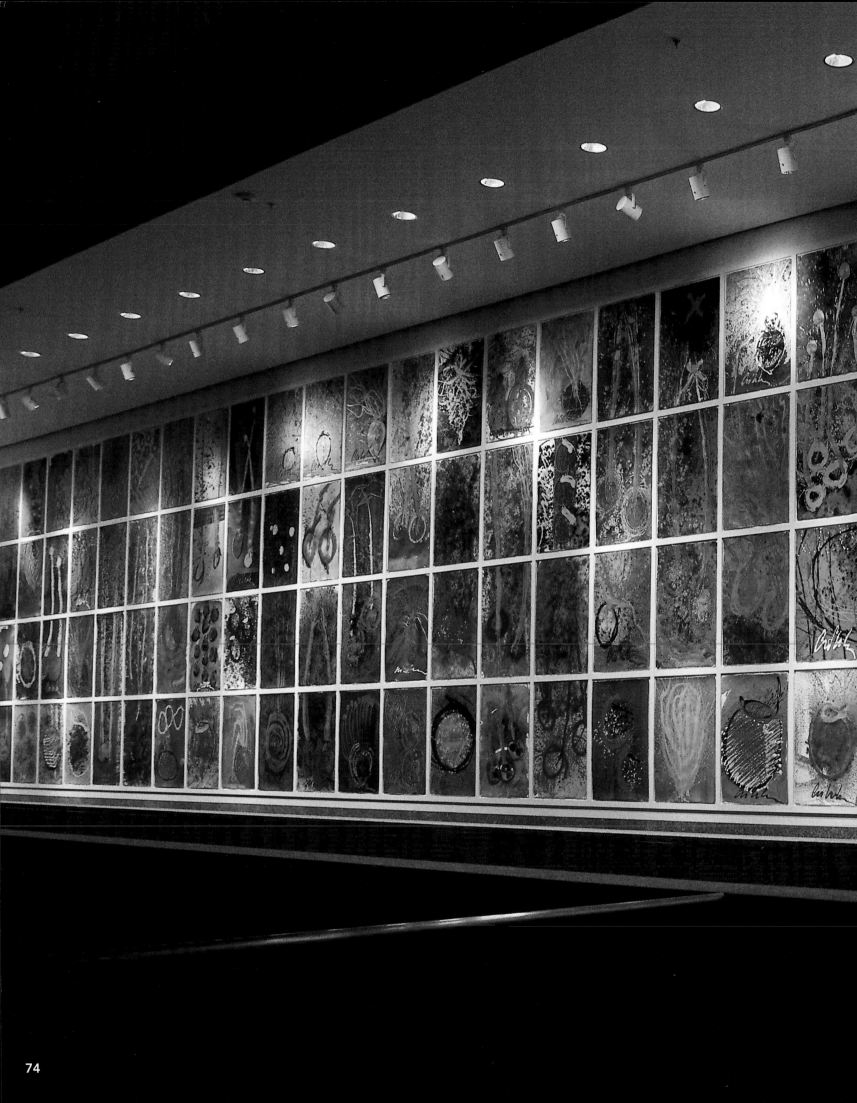

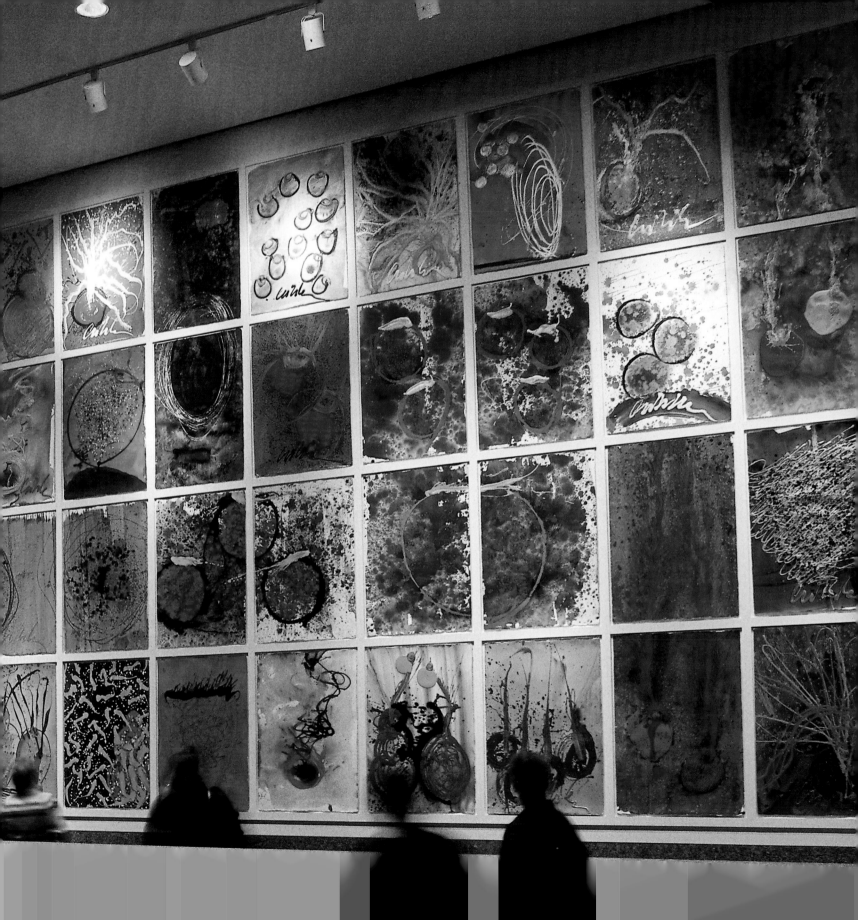

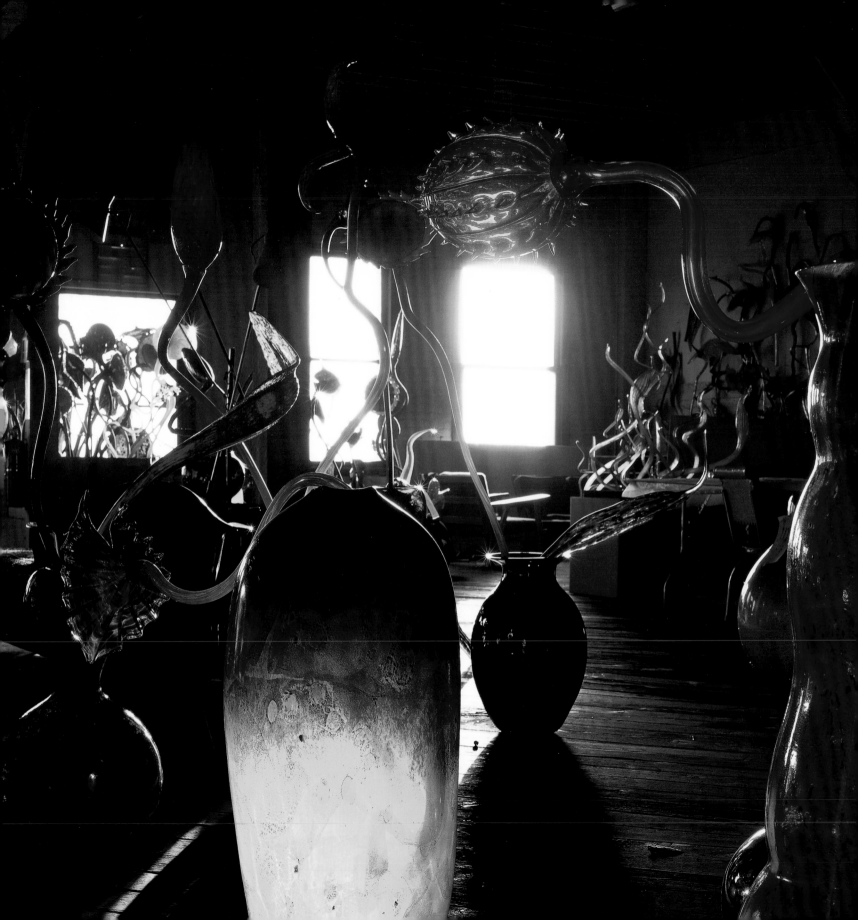

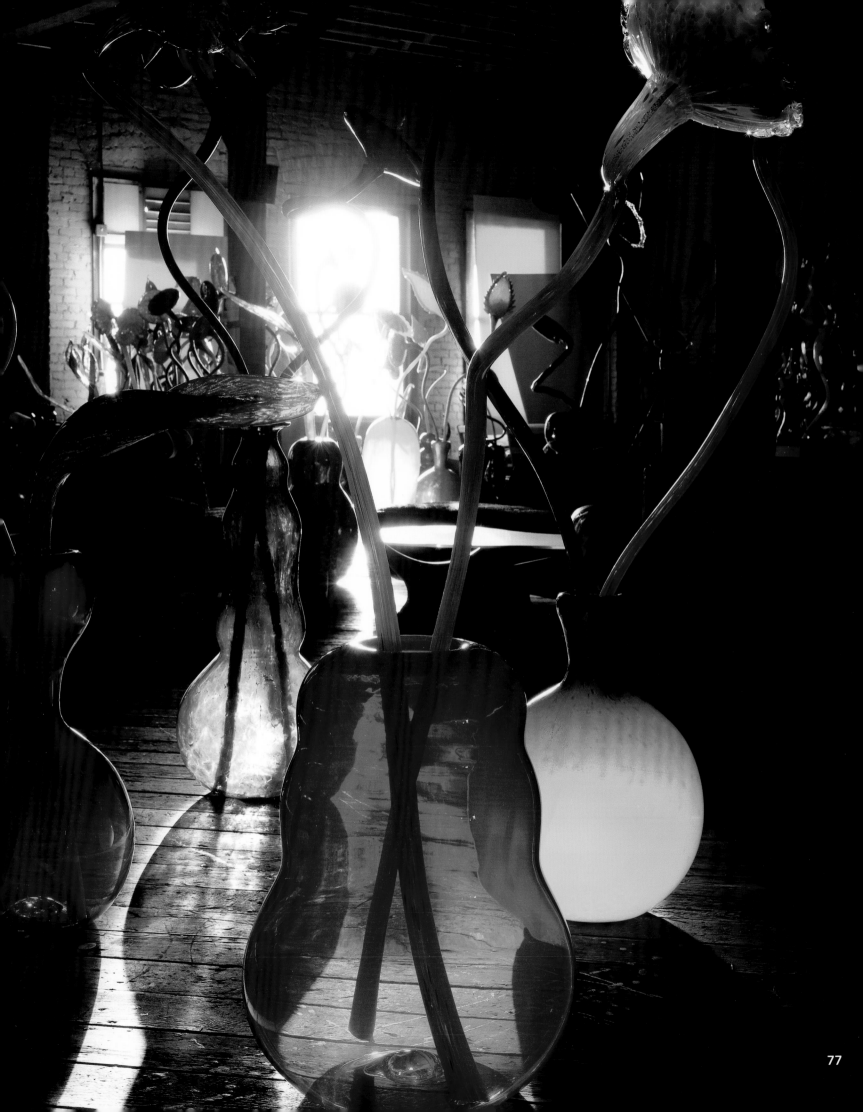

Chronology

1941 Born September 20 in Tacoma, Washington, to George Chihuly and Viola Magnuson Chihuly.

1957 Older brother and only sibling, George, is killed in a Navy Air Force training accident in Pensacola, Florida.

1958 His father suffers a fatal heart attack at age 51. His mother goes to work to support herself and Dale.

1959 Graduates from high school in Tacoma. Enrolls in the College of Puget Sound (now the University of Puget Sound) in his hometown. Transfers to the University of Washington in Seattle to study interior design and architecture.

1961 Joins Delta Kappa Epsilon fraternity and becomes rush chairman. Learns to melt and fuse glass.

1962 Disillusioned with school, he interrupts his studies and travels to Florence to study art. Discouraged by not being able to speak Italian, he leaves and travels to the Middle East.

1963 Works on a kibbutz in the Negev Desert. Returns to the University of Washington in the College of Arts and Sciences and studies under Hope Foote and Warren Hill. In a weaving class with Doris Brockway, he incorporates glass shards into woven tapestries.

1964 Returns to Europe, visits Leningrad, and makes the first of many trips to Ireland.

1965 Receives B.A. in Interior Design from the University of Washington. Experimenting on his own in his basement studio, Chihuly blows his first glass bubble by melting stained glass and using a metal pipe.

1966 Works as a commercial fisherman in Alaska to earn money for graduate school. Enters the University of Wisconsin at Madison, where he studies glassblowing under Harvey Littleton.

1967 Receives M.S. in Sculpture from the University of Wisconsin. Enrolls at the Rhode Island School of Design (RISD) in Providence, where he begins his exploration of environmental works using neon, argon, and blown glass. Awarded a Louis Comfort Tiffany Foundation Grant for work in glass. Italo Scanga, then on the faculty at Pennsylvania State University's Art Department, lectures at RISD, and the two begin a lifelong friendship.

1968 Receives M.F.A. in Ceramics from RISD. Awarded a Fulbright Fellowship, which enables him to travel and work in Europe. Becomes the first American glassblower to work in the Venini factory on the island of Murano. Returns to the United States and spends the first of four consecutive summers teaching at Haystack Mountain School of Crafts in Deer Isle, Maine.

1969 Travels again throughout Europe and meets glass masters Erwin Eisch in Germany and Jaroslava Brychtová and Stanislav Libenský in Czechoslovakia. Returning to the United States, Chihuly establishes the glass program at RISD, where he teaches for the next eleven years.

1970 Meets James Carpenter, a student in the RISD illustration department, and they begin a four-year collaboration.

1971 On the site of a tree farm donated by Seattle art patrons Anne Gould Hauberg and John Hauberg, the Pilchuck Glass School is created. Chihuly's first environmental installation at Pilchuck is created that summer. In the fall, at RISD, he creates "20,000 Pounds of Ice and Neon" and "Glass Forest #1," and "Glass Forest #2" with James Carpenter, installations that prefigure later environmental works by Chihuly.

1972 Continues to collaborate with Carpenter on large-scale architectural projects. They create "Rondel Door" and "Cast Glass Door" at Pilchuck. Back in Providence, they create "Dry Ice, Bent Glass and Neon," a conceptual breakthrough.

1974 Supported by a National Endowment for the Arts grant at Pilchuck, James Carpenter, a group of students, and he develop a technique for picking up glass thread drawings. In December at RISD, he completes his last collaborative project with Carpenter, "Corning Wall."

1975 At RISD, begins series of "Navajo Blanket Cylinders." Kate Elliott and, later, Flora Mace fabricate the complex thread drawings. He receives the first of two National Endowment for the Arts Individual Artist grants. Artist-in-residence with Seaver Leslie at Artpark, on the Niagara Gorge, in New York State. Begins "Irish" and "Ulysses" cylinders with Leslie and Mace.

1976 An automobile accident in England leaves him, after weeks in the hospital and 256 stitches in his face, without sight in his left eye and with permanent damage to his right ankle and foot. After recuperating, he returns to Providence to serve as head of the Department of Sculpture and the Program in Glass at RISD. Henry Geldzahler, curator of contemporary art at the Metropolitan Museum of Art in New York, acquires three "Navajo Blanket Cylinders" for the museum's collection. This is a turning point in Chihuly's career, and a friendship between artist and curator commences.

1977 Inspired by Northwest Coast Indian baskets he sees at the Washington Historical Society in Tacoma, begins the "Basket" series at Pilchuck over the summer, with Benjamin Moore as his assistant gaffer. Continues his bicoastal teaching assignments, dividing his time between Rhode Island and the Pacific Northwest.

1978 Meets William Morris, a student at Pilchuck Glass School, and the two begin a close, eight-year working relationship. A solo show curated by Michael W. Monroe at the Renwick Gallery, Smithsonian Institution, in Washington, D.C., is another milestone in Chihuly's career.

1979 Dislocates his shoulder in a bodysurfing accident and relinquishes the gaffer position for good. William Morris becomes his chief gaffer for the next several years. Chihuly begins to make drawings as a way to communicate his designs.

1980 Resigns his teaching position at RISD. He returns there periodically during the 1980s as artist-in-residence. Begins "Seaform Series" at Pilchuck in the summer and later, back in Providence, returns to architectural installations with the creation of windows for the Shaare Emeth Synagogue in St. Louis, Missouri.

1981 Begins "Macchia" series.

1982 First major catalog is published: "Chihuly Glass," designed by an RISD colleague and friend, Malcolm Grear.

1983 Returns to the Pacific Northwest after sixteen years on the East Coast. Works at Pilchuck in the fall and winter, further developing the "Macchia" series with William Morris as chief gaffer.

1984 Begins work on the "Soft Cylinder" series with Flora Mace and Joey Kirkpatrick executing the glass drawings.

1985 Begins working hot glass on a larger scale and creates several site-specific installations.

1986 Begins "Persian" series with Martin Blank, a former RISD student and assistant, as gaffer. With the opening of "Objets de Verre" at the Musée des Arts Décoratifs, Palais du Louvre, in Paris, he becomes one of only four American artists to have had a one-person exhibition at the Louvre.

1987 Establishes his first hotshop in the Van de Kamp building near Lake Union. Begins association with artist Parks Anderson. Marries playwright Sylvia Peto.

1988 Inspired by a private collection of Italian art-deco glass, Chihuly begins "Venetian" series. Working from Chihuly's drawings, Lino Tagliapietra serves as gaffer.

1989 With Italian glass masters Lino Tagliapietra, Pino Signoretto, and a team of glassblowers at Pilchuck Glass School, begins "Putti Venetian" series. Working with Tagliapietra, Chihuly creates "Ikebana" series, inspired by his travels to Japan and exposure to ikebana masters.

1990 Purchases the historic Pocock Building located on Lake Union, realizing his dream of being on the water in Seattle. Renovates the

building and names it The Boathouse, for use as a studio, hotshop, archives, and residence. Travels to Japan.

1991 Begins "Niijima Float" series with Rich Royal as gaffer, creating some of the largest pieces of glass ever blown by hand. Completes a number of large-scale architectural installations. He and Sylvia Peto divorce.

1992 Begins "Chandelier" series with a large-scale hanging sculpture at the Seattle Art Museum. Designs sets for Seattle Opera production of Debussy's "Pelléas et Mélisande."

1993 Begins "Piccolo Venetian" series with Lino Tagliapietra. Creates "100,000 Pounds of Ice and Neon," a temporary installation in the Tacoma Dome, Tacoma, Washington.

1994 Creates five large-scale installations for Tacoma's Union Station Federal Courthouse. Hilltop Artists in Residence, a glassblowing program for at-risk youths in Tacoma, Washington, is created by friend Kathy Kaperick; Chihuly assists with instruction of youths and is a major contributor.

1995 "Chihuly Over Venice" begins with a glassblowing session in Nuutajärvi, Finland, and a subsequent blow at the Waterford Crystal factory, Ireland.

1996 "Chihuly Over Venice" continues with a blow in Monterrey, Mexico, and culminates with the installation of fourteen "Chandeliers" at various sites in Venice. Creates his first permanent outdoor installation, "Icicle Creek Chandelier."

1997 Continues and expands series of experimental plastics he calls "polyvitro." "Chihuly" is designed by Massimo Vignelli and co-published by Harry N. Abrams, Inc., New York, and Portland Press, Seattle. A permanent installation of Chihuly's work opens at the Hakone Glass Forest, Ukai Museum, in Hakone, Japan.

1998 Chihuly is invited to Sydney, Australia, with his team to participate in the Sydney Arts Festival. A son, Jackson Viola Chihuly, is born February 12 to Dale Chihuly and Leslie Jackson. Hilltop Artists in Residence program expands to Taos, New Mexico, to work with Taos Pueblo Native Americans. Creates

architectural installations for Benaroya Hall, Seattle; the Bellagio, Las Vegas; and Atlantis on Paradise Island, Bahamas.

1999 Begins "Jerusalem Cylinder" series. Mounts his most ambitious exhibition to date: "Chihuly in the Light of Jerusalem 2000," at the Tower of David Museum of the History of Jerusalem. Outside the museum, he creates a sixty-foot wall from twenty-four massive blocks of ice shipped from Alaska.

2000 Creates "La Tour de Lumière" sculpture as part of the exhibition "Contemporary American Sculpture in Monte Carlo." Marlborough Gallery represents Chihuly. More than a million visitors enter the Tower of David Museum to see "Chihuly in the Light of Jerusalem 2000," breaking the world attendance record for a temporary exhibition during 1999–2000.

2001 "Chihuly at the V&A" opens at the Victoria and Albert Museum in London. Exhibits at Marlborough Gallery, New York and London. Creates a series of intertwining "Chandeliers" for the Gonda Bulilding at the Mayo Clinic in Rochester, Minnesota. Begins major commission for the Universal Oceanographic Park in Valencia, Spain, and exhibits artwork throughout the city.

Museum Collections

Akita Senshu Museum of Art, Akita, Japan
Akron Art Museum, Akron, Ohio
Albany Museum of Art, Albany, Georgia
Albright-Knox Art Gallery, Buffalo, New York
Allied Arts Association, Richland, Washington
American Craft Museum, New York, New York
Amon Carter Museum, Fort Worth, Texas
Anchorage Museum of History and Art, Anchorage, Alaska
Arizona State University Art Museum, Tempe, Arizona
Arkansas Arts Center, Little Rock, Arkansas
Art Gallery of Greater Victoria, Victoria, British Columbia, Canada
Art Gallery of Western Australia, Perth, Australia
Art Museum of Missoula, Missoula, Montana
Art Museum of Southeast Texas, Beaumont, Texas
Asheville Art Museum, Asheville, North Carolina
Auckland Museum, Auckland, New Zealand
Azabu Museum of Arts and Crafts, Tokyo, Japan
Ball State University Museum of Art, Muncie, Indiana
Beach Museum of Art, Kansas State University, Manhattan, Kansas
Bellevue Art Museum, Bellevue, Washington
Berkeley Art Museum, University of California, Berkeley, California
Birmingham Museum of Art, Birmingham, Alabama
Boarman Arts Center, Martinsburg, West Virginia
Boca Raton Museum of Art, Boca Raton, Florida
Brooklyn Museum, Brooklyn, New York
Canadian Craft Museum, Vancouver, British Columbia, Canada
Carnegie Museum of Art, Pittsburgh, Pennsylvania
Charles A. Wustum Museum of Fine Arts, Racine, Wisconsin
Chrysler Museum of Art, Norfolk, Virginia
Cincinnati Art Museum, Cincinnati, Ohio
Cleveland Center for Contemporary Art, Cleveland, Ohio
Cleveland Museum of Art, Cleveland, Ohio
Columbus Cultural Arts Center, Columbus, Ohio
Columbus Museum of Art, Columbus, Ohio
Contemporary Arts Center, Cincinnati, Ohio
Contemporary Crafts Association and Gallery, Portland, Oregon
Contemporary Museum, Honolulu, Hawaii
Cooper-Hewitt, National Design Museum, Smithsonian Institution, New York, New York
Corning Museum of Glass, Corning, New York
Crocker Art Museum, Sacramento, California
Currier Gallery of Art, Manchester, New Hampshire
Daiichi Museum, Nagoya, Japan
Dallas Museum of Art, Dallas, Texas
Danske Kunstindustrimuseum, Copenhagen, Denmark
Dayton Art Institute, Dayton, Ohio

DeCordova Museum and Sculpture Park, Lincoln, Massachusetts
Delaware Art Museum, Wilmington, Delaware
Denver Art Museum, Denver, Colorado
Detroit Institute of Arts, Detroit, Michigan
Dowse Art Museum, Lower Hutt, New Zealand
Elvehjem Museum of Art, University of Wisconsin, Madison, Wisconsin
Eretz Israel Museum, Tel Aviv, Israel
Everson Museum of Art, Syracuse, New York
Fine Arts Institute, Edmond, Oklahoma
Flint Institute of Arts, Flint, Michigan
Glasmuseum, Ebeltoft, Denmark
Glasmuseum, Frauenau, Germany
Glasmuseum alter Hof Herding, Glascollection, Ernsting, Germany
Glasmuseum Wertheim, Wertheim, Germany
Grand Rapids Art Museum, Grand Rapids, Michigan
Hakone Glass Forest, Ukai Museum, Hakone, Japan
Hawke's Bay Exhibition Centre, Hastings, New Zealand
High Museum of Art, Atlanta, Georgia
Hiroshima City Museum of Contemporary Art, Hiroshima, Japan
Hokkaido Museum of Modern Art, Hokkaido, Japan
Honolulu Academy of Arts, Honolulu, Hawaii
Hunter Museum of American Art, Chattanooga, Tennessee
Indianapolis Museum of Art, Indianapolis, Indiana
Israel Museum, Jerusalem, Israel
Japan Institute of Arts and Crafts, Tokyo, Japan
Jesse Besser Museum, Alpena, Michigan
Jesuit Dallas Museum, Dallas, Texas
Joslyn Art Museum, Omaha, Nebraska
Jundt Art Museum, Gonzaga University, Spokane, Washington
Kalamazoo Institute of Arts, Kalamazoo, Michigan
Kaohsiung Museum of Fine Arts, Kaohsiung, Taiwan
Kemper Museum of Contemporary Art & Design, Kansas City, Missouri
Kestner-Gesellschaft, Hannover, Germany
Kobe City Museum, Kobe, Japan
Krannert Art Museum, University of Illinois, Champaign, Illinois
Krasl Art Center, St. Joseph, Michigan
Kunstmuseum Düsseldorf, Düsseldorf, Germany
Kunstsammlungen der Veste Coburg, Coburg, Germany
Kurita Museum, Tochigi, Japan
Leigh Yawkey Woodson Art Museum, Wausau, Wisconsin
Lobmeyr Museum, Vienna, Austria
Los Angeles County Museum of Art, Los Angeles, California
Lowe Art Museum, University of Miami, Coral Gables, Florida
Lyman Allyn Art Museum, New London, Connecticut
M.H. de Young Memorial Museum, San Francisco, California
Madison Art Center, Madison, Wisconsin
Manawatu Museum, Palmerston North, New Zealand
Matsushita Art Museum, Kagoshima, Japan
Meguro Museum of Art, Tokyo, Japan
Memorial Art Gallery, University of Rochester, Rochester, New York
Metropolitan Museum of Art, New York, New York

Milwaukee Art Museum, Milwaukee, Wisconsin
Minneapolis Institute of Arts, Minneapolis, Minnesota
Mint Museum of Craft + Design, Charlotte, North Carolina
Mobile Museum of Art, Mobile, Alabama
Modern Art Museum of Fort Worth, Fort Worth, Texas
Morris Museum, Morristown, New Jersey
Musée d'Art Moderne et d'Art Contemporain, Nice, France
Musée des Arts Décoratifs, Lausanne, Switzerland
Musée des Arts Décoratifs, Palais du Louvre, Paris, France
Musée des Arts Décoratifs de Montréal, Montreal, Quebec, Canada
Musée des Beaux-Arts et de la Céramique, Rouen, France
Musée Provincial Sterckshof, Antwerp, Belgium
Museo del Vidrio, Monterrey, Mexico
Museum Bellerive, Zurich, Switzerland
Museum Boijmans Van Beuningen, Rotterdam, The Netherlands
Museum für Kunst und Gewerbe Hamburg, Hamburg, Germany
Museum für Kunsthandwerk, Frankfurt am Main, Germany
Museum of American Glass at Wheaton Village, Millville, New Jersey
Museum of Art, Fort Lauderdale, Florida
Museum of Art, Rhode Island School of Design, Providence, Rhode Island
Museum of Art and Archaeology, Columbia, Missouri
Museum of Arts and Sciences, Daytona Beach, Florida
Museum of Contemporary Art, Chicago, Illinois
Museum of Contemporary Art at San Diego, La Jolla, California
Museum of Fine Arts, Boston, Massachusetts
Museum of Fine Arts, St. Petersburg, Florida
Museum of Modern Art, New York, New York
Museum of Northwest Art, La Conner, Washington
Museum voor Sierkunst en Vormgeving, Ghent, Belgium
Muskegon Museum of Art, Muskegon, Michigan
Muzeum města Brna, Brno, Czech Republic
Muzeum skla a bižuterie, Jablonec nad Nisou, Czech Republic
Naples Museum of Art, Naples, Florida
National Gallery of Australia, Canberra, Australia
National Gallery of Victoria, Melbourne, Australia
National Liberty Museum, Philadelphia, Pennsylvania
National Museum Kyoto, Kyoto, Japan
National Museum of American History, Smithsonian Institution, Washington, D.C.
National Museum of Modern Art Kyoto, Kyoto, Japan
National Museum of Modern Art Tokyo, Tokyo, Japan
Nationalmuseum, Stockholm, Sweden
New Orleans Museum of Art, New Orleans, Louisiana
Newport Harbor Art Museum, Newport Beach, California
Niijima Contemporary Art Museum, Niijima, Japan
North Central Washington Museum, Wenatchee, Washington
Notojima Glass Art Museum, Ishikawa, Japan
O Art Museum, Tokyo, Japan
Otago Museum, Dunedin, New Zealand
Palm Beach Community College Museum of Art, Lake Worth, Florida
Palm Springs Desert Museum, Palm Springs, California
Palmer Museum of Art, Pennsylvania State University, University Park, Pennsylvania

Parrish Art Museum, Southampton, New York
Philadelphia Museum of Art, Philadelphia, Pennsylvania
Phoenix Art Museum, Phoenix, Arizona
Plains Art Museum, Fargo, North Dakota
Portland Art Museum, Portland, Oregon
Powerhouse Museum, Sydney, Australia
Princeton University Art Museum, Princeton, New Jersey
Queensland Art Gallery, South Brisbane, Australia
Robert McDougall Art Gallery, Christchurch, New Zealand
Royal Ontario Museum, Toronto, Ontario, Canada
Saint Louis Art Museum, St. Louis, Missouri
Samuel P. Harn Museum of Art, University of Florida, Gainesville, Florida
San Francisco Museum of Modern Art, San Francisco, California
San Jose Museum of Art, San Jose, California
Scitech Discovery Centre, Perth, Australia
Scottsdale Center for the Arts, Scottsdale, Arizona
Seattle Art Museum, Seattle, Washington
Shimonoseki City Art Museum, Shimonoseki, Japan
Singapore Art Museum, Singapore
Smith College Museum of Art, Northampton, Massachusetts
Smithsonian American Art Museum, Washington, D.C.
Sogetsu Art Museum, Tokyo, Japan
Speed Art Museum, Louisville, Kentucky
Spencer Museum of Art, University of Kansas, Lawrence, Kansas
Springfield Museum of Fine Arts, Springfield, Massachusetts
Suntory Museum of Art, Tokyo, Japan
Suomen Lasimuseo, Riihimäki, Finland
Suwa Garasu no Sato Museum, Nagano, Japan
Tacoma Art Museum, Tacoma, Washington
Taipei Fine Arts Museum, Taipei, Taiwan
Tochigi Prefectural Museum of Fine Arts, Tochigi, Japan
Toledo Museum of Art, Toledo, Ohio
Uměleckoprůmsylové muzeum, Prague, Czech Republic
Utah Museum of Fine Arts, University of Utah, Salt Lake City, Utah
Victoria and Albert Museum, London, England
Wadsworth Atheneum, Hartford, Connecticut
Waikato Museum of Art and History, Hamilton, New Zealand
Walker Hill Art Center, Seoul, Korea
Whatcom Museum of History and Art, Bellingham, Washington
White House Collection of American Crafts, Washington, D.C.
Whitney Museum of American Art, New York, New York
Württembergisches Landesmuseum Stuttgart, Stuttgart, Germany
Yale University Art Gallery, New Haven, Connecticut
Yokohama Museum of Art, Yokohama, Japan

Museum Exhibitions

1967 **Dale Chihuly**
University of Wisconsin, Madison, Wisconsin

1971 **Glass Environment: Dale Chihuly & James Carpenter**
American Craft Museum, New York, New York

1975 **Dale Chihuly: Indian Blanket Cylinders**
Utah Museum of Fine Arts, Salt Lake City, Utah
Institute of American Indian Arts Museum, Santa Fe, New Mexico

1976 **Dale Chihuly: Glass Cylinders**
Wadsworth Atheneum, Hartford, Connecticut
Dale Chihuly: Indian Blanket Cylinders
David Winton Bell Gallery, Brown University, Providence, Rhode Island
Leigh Yawkey Woodson Art Museum, Wausau, Wisconsin

1978 **Baskets and Cylinders: Recent Glass by Dale Chihuly**
Renwick Gallery, National Museum of American Art, Smithsonian Institution,
Washington, D.C.

1979 **Dale Chihuly/VIDRO**
Museu de Arte de São Paulo, São Paulo, Brazil

1980 **Dale Chihuly: An American Glass Artist**
Eretz Israel Museum, Tel Aviv, Israel
Dale Chihuly: Recent Works
Fine Arts Center Galleries, University of Rhode Island, Kingston, Rhode Island

1981 **Dale Chihuly: Glass**
Tacoma Art Museum, Tacoma, Washington

1982 **Dale Chihuly: Glass**
Phoenix Art Museum, Phoenix, Arizona
Dale Chihuly: Recent Works in Glass
Tucson Museum of Art, Tucson, Arizona
San Diego Museum of Art, San Diego, California

1983 **Dale Chihuly: Recent Works in Glass**
Saint Louis Art Museum, St. Louis, Missouri
Palm Springs Desert Museum, Palm Springs, California

1984 **Chihuly: A Decade of Glass**
Bellevue Art Museum, Bellevue, Washington
Modern Art Museum of Fort Worth, Fort Worth, Texas
Dale Chihuly: Recent Works in Glass
Crocker Art Museum, Sacramento, California

1985 **Chihuly: A Decade of Glass**
Arkansas Arts Center, Little Rock, Arkansas
Madison Art Center, Madison, Wisconsin
Palmer Museum of Art, Pennsylvania State University, University Park, Pennsylvania
University Galleries, Illinois State University, Normal, Illinois

1986 **Chihuly: A Decade of Glass**
Brunnier Art Museum, Iowa State University, Ames, Iowa
Chicago Cultural Center, Chicago, Illinois
Mint Museum of Art, Charlotte, North Carolina
Muskegon Museum of Art, Muskegon, Michigan
Musée des Arts Décoratifs de Montréal, Montreal, Quebec, Canada
Dale Chihuly: Objets de Verre
Musée des Arts Décoratifs, Palais du Louvre, Paris, France

1987 **Chihuly: A Decade of Glass**
Fred Jones Jr. Museum of Art, University of Oklahoma, Norman, Oklahoma
Art Museum of Western Virginia, Roanoke, Virginia
Dale Chihuly: Objets de Verre
Musée Matisse, Le Cateau–Cambrésis, France

1988 **Chihuly: Persians**
DIA Art Foundation, Bridgehampton, New York
Dale Chihuly: Objets de Verre
Fundação Calouste Gulbenkian, Lisbon, Portugal
Musée d'Unterlinden, Colmar, France

1989 **Chihuly: Persians**
Society for Contemporary Craft, Pittsburgh, Pennsylvania
20ª Bienal Internacional de São Paulo
São Paulo, Brazil

1990 **Chihuly: Glass Master**
Museo Nacional de Bellas Artes, Santiago, Chile
Dale Chihuly: Japan 1990
Azabu Museum of Arts and Crafts, Tokyo, Japan
Dale Chihuly: Persians
Hudson River Museum of Westchester, Yonkers, New York

1991 **Chihuly: Venetians**
Uměleckoprůmyslové muzeum, Prague, Czech Republic
Röhsska Konstslöjdmuseet, Göteborg, Sweden

1992 **Chihuly Courtyards**
Honolulu Academy of Arts, Honolulu, Hawaii
Dale Chihuly: Glass
Taipei Fine Arts Museum, Taipei, Taiwan
Dale Chihuly: Installations
Seattle Art Museum, Seattle, Washington
Contemporary Arts Center, Cincinnati, Ohio
Dale Chihuly: Venetians
Museum für Kunst und Gewerbe Hamburg, Hamburg, Germany
Nationaal Glasmuseum, Leerdam, The Netherlands
Museum voor modern kunst, Oostende, Belgium
Dale Chihuly
Toledo Museum of Art, Toledo, Ohio

1993 **Chihuly: alla Macchia**
Art Museum of Southeast Texas, Beaumont, Texas
Chihuly in Australia: Glass and Works on Paper
Powerhouse Museum, Sydney, Australia
National Gallery of Victoria, Melbourne, Australia
Scitech Discovery Centre, Perth, Australia
Chihuly: Form from Fire
Lowe Art Museum, University of Miami, Coral Gables, Florida
Tampa Museum of Art, Tampa, Florida
Museum of Arts and Sciences, Daytona Beach, Florida
Dale Chihuly: Installations
Detroit Institute of Arts, Detroit, Michigan
Dale Chihuly: Virtuose Spiele in Glas
Altes Zeughaus Landenberg, Sarnen, Switzerland
Historiches Museum, Sarnen, Switzerland

1994 **Chihuly: alla Macchia**
Austin Museum of Art–Laguna Gloria, Austin, Texas
Chihuly Baskets
North Central Washington Museum, Wenatchee, Washington
Port Angeles Fine Arts Center, Port Angeles, Washington
Chihuly: Form from Fire
Philharmonic Center for the Arts, Naples, Florida
Center for the Arts, Vero Beach, Florida
Samuel P. Harn Museum of Art, University of Florida, Gainesville, Florida
Museum of Fine Arts, Florida State University, Tallahassee, Florida
Chihuly: Glass in Architecture
Kaohsiung Museum of Fine Arts, Kaohsiung, Taiwan
Dale Chihuly: Installations
Dallas Museum of Art, Dallas, Texas
Santa Barbara Museum of Art, Santa Barbara, California
Chihuly in New Zealand: Glass and Works on Paper
Dowse Art Museum, Lower Hutt, New Zealand
Waikato Museum of Art and History, Hamilton, New Zealand
Otago Museum, Dunedin, New Zealand
Robert McDougall Art Gallery, Christchurch, New Zealand
Manawatu Museum, Palmerston North, New Zealand
Dale Chihuly: Pelléas and Mélisande
Renwick Gallery, National Museum of American Art, Smithsonian Institution, Washington, D.C.

1995 **Chihuly: alla Macchia**
Polk Museum of Art, Lakeland, Florida
Grace Museum, Abilene, Texas
Chihuly Baskets
Washington State Historical Society Museum, Tacoma, Washington
Maryhill Museum of Art, Goldendale, Washington
Sheehan Gallery, Whitman College, Walla Walla, Washington
Chihuly: Form from Fire
Saint John's Museum of Art, Wilmington, North Carolina
Chihuly in New Zealand: Glass and Works on Paper
Hawke's Bay Exhibition Centre, Hastings, New Zealand
Auckland Museum, Auckland, New Zealand
Dale Chihuly
Jundt Art Museum, Gonzaga University, Spokane, Washington
Dale Chihuly: Installations
Anchorage Museum of History and Art, Anchorage, Alaska
San Jose Museum of Art, San Jose, California

Dale Chihuly: On Site
Jacksonville Museum of Contemporary Art, Jacksonville, Florida

1996 **Alaska Baskets**
Alutiiq Museum and Archaeological Repository, Kodiak, Alaska
Sheldon Museum and Cultural Center, Haines, Alaska
Sheldon Jackson Museum, Sitka, Alaska
Chihuly: alla Macchia
Brevard Museum of Art and Science, Melbourne, Florida
Leigh Yawkey Woodson Art Museum, Wausau, Wisconsin
Chihuly Baskets
Art Museum of Missoula, Missoula, Montana
Schneider Museum of Art, Southern Oregon State College, Ashland, Oregon
University of Wyoming Art Museum, Laramie, Wyoming
Scottsdale Center for the Arts, Scottsdale, Arizona
Chihuly Over Venice
Kemper Museum of Contemporary Art & Design, Kansas City, Missouri
Chihuly: Seaforms
Corcoran Gallery of Art, Washington, D.C.
Museum of Art, Williams College, Williamstown, Massachusetts
Portland Museum of Art, Portland, Maine
Crystal Gardens
LongHouse Foundation, East Hampton, New York
Dale Chihuly: Installations
Contemporary Arts Center, New Orleans, Louisiana
Baltimore Museum of Art, Baltimore, Maryland
Saint Louis Art Museum, St. Louis, Missouri
Dale Chihuly: On Site
Palm Springs Desert Museum, Palm Springs, California

1997 **Alaska Baskets**
Carrie M. McLain Memorial Museum, Nome, Alaska
Pratt Museum, Homer, Alaska
Valdez Museum and Historical Archive, Valdez, Alaska
Tongass Historical Museum, Ketchikan, Alaska
Chihuly Baskets
Allied Arts Association, Richland, Washington
Prichard Art Gallery, University of Idaho, Moscow, Idaho
Chihuly: The George R. Stroemple Collection
Portland Art Museum, Portland, Oregon
Chihuly Over Venice
Corcoran Gallery of Art, Washington, D.C.
Portland Art Museum, Portland, Oregon
Chihuly: Seaforms
Middlebury College Museum of Art, Middlebury, Vermont
Everson Museum of Art, Syracuse, New York
Heckscher Museum of Art, Huntington, New York
Dale Chihuly: Installations
Minneapolis Institute of Arts, Minneapolis, Minnesota
Dixon Gallery and Gardens, Memphis, Tennessee
Albright-Knox Art Gallery, Buffalo, New York
The Magic of Chihuly Glass
Kobe City Museum, Kobe, Japan
Suntory Museum of Art, Tokyo, Japan

1998 **Alaska Baskets**
 Skagway Museum and Archives, Skagway, Alaska
 Chihuly Baskets
 West Sound Arts Council, Bremerton, Washington
 Alaska State Museum, Juneau, Alaska
 Chihuly Over Venice
 Columbus Museum of Art, Columbus, Ohio
 Chihuly: Seaforms
 Memorial Art Gallery, University of Rochester, Rochester, New York
 New Britain Museum of American Art, New Britain, Connecticut
 Ball State University Museum of Art, Muncie, Indiana
 Dale Chihuly: Installations
 Norton Museum of Art, West Palm Beach, Florida
 Dale Chihuly: On Site
 Albuquerque Museum of Art and History, Albuquerque, New Mexico
 The Magic of Chihuly Glass
 Fukuoka Art Museum, Fukuoka, Japan
 Montana Macchia
 Holter Museum of Art, Helena, Montana
 Paris Gibson Square Museum of Art, Great Falls, Montana
 Hockaday Center for the Arts, Kalispell, Montana
 Custer County Art Center, Miles City, Montana
 Dale Chihuly
 University Art Gallery, University of California–San Diego, La Jolla, California
 Chihuly: The George R. Stroemple Collection
 Akron Art Museum, Akron, Ohio
 Dale Chihuly: Venetians
 Providence Athenaeum, Providence, Rhode Island

1999 **Chihuly in the Light of Jerusalem 2000**
 Tower of David Museum of the History of Jerusalem, Jerusalem, Israel
 Chihuly Baskets
 Delaware Art Museum, Wilmington, Delaware
 Plains Art Museum, Fargo, North Dakota
 Chihuly Over Venice
 Columbus Museum of Art, Columbus, Ohio
 Chihuly: Glass Master
 Hsinchu Municipal Cultural Center, Hsinchu, Taiwan
 Chihuly: Macchia
 Northwest Art Center, Minot State University, Minot, North Dakota
 North Dakota Museum of Art, Grand Forks, North Dakota
 Rourke Art Gallery, Moorhead, Minnesota
 Chihuly: Seaforms
 Palmer Museum of Art, Pennsylvania State University, University Park, Pennsylvania
 Indianapolis Museum of Art, Columbus Gallery, Columbus, Indiana
 Dale Chihuly: Installations
 Hiroshima City Museum of Contemporary Art, Hiroshima, Japan
 Contemporary Art Center of Virginia, Virginia Beach, Virginia
 Mint Museum of Craft + Design, Charlotte, North Carolina
 Dale Chihuly: Masterworks in Glass
 National Gallery of Australia, Canberra, Australia
 Dale Chihuly: The George R. Stroemple Collection
 California Center for the Arts, Escondido, California

2000 **Chihuly Baskets**
 Braithwaite Fine Arts Gallery, Southern Utah University, Cedar City, Utah
 Brigham Young University Museum of Art, Provo, Utah
 Chihuly: Inside and Out
 Joslyn Art Museum, Omaha, Nebraska
 Chihuly: Seaforms
 Fuller Museum of Art, Brockton, Massachusetts
 Fayetteville Museum of Art, Fayetteville, North Carolina
 Dale Chihuly: Installations
 Knoxville Museum of Art, Knoxville, Tennessee
 Arkansas Arts Center, Little Rock, Arkansas
 Chihuly in Iceland: Form from Fire
 Listasafn Reykjavíkur, Reykjavík, Iceland
 Reflections of Chihuly: A Naples Museum of Art Inaugural Exhibition
 Naples Museum of Art, Naples, Florida
 Dale Chihuly: On Site
 Nevada Museum of Art, Reno, Nevada
 Dale Chihuly: The George R. Stroemple Collection
 San Jose Museum of Art, San Jose, California
 Chihuly: Masterworks in Glass
 JamFactory Contemporary Craft and Design, Adelaide, Australia

2001 **Chihuly: Seaforms**
 Bowers Museum of Cultural Art, Santa Ana, California
 Springfield Museum of Fine Arts, Springfield, Massachusetts
 Southern Vermont Art Center, Manchester, Vermont
 Chihuly Baskets
 Crocker Art Museum, Sacramento, California
 Loveland Museum of Art, Loveland, Colorado
 Lauren Rogers Museum of Art, Laurel, Mississippi
 Tyler Museum of Art, Tyler, Texas
 Chihuly at the V&A
 Victoria and Albert Museum, London, England
 Form from Fire: Glass Works by Dale Chihuly
 Dayton Art Institute, Dayton, Ohio
 Dale Chihuly: The George R. Stroemple Collection
 Las Vegas Art Museum, Las Vegas, Nevada
 Boise Art Museum, Boise, Idaho
 Chihuly Over Venice
 Milwaukee Art Museum, Milwaukee, Wisconsin

Marlborough

New York
Marlborough Gallery, Inc.
40 West 57th Street
New York, NY 10019
Telephone 212.541.4900
Telefax 212.541.4948
www.marlboroughgallery.com
mny@marlboroughgallery.com

Marlborough Chelsea
211 West 19th Street
New York, NY 10011
Telephone 212.463.8634
Telefax 212.463.9658
IPAMarlborough@netzero.com

Florida
Marlborough Florida
Gallery Center
608 Banyan Trail
Boca Raton, FL 33431
Telephone 561.999.9932
Telefax 561.999.9610

Agents for:
Magdalena Abakanowicz
Avigdor Arikha
Fernando Botero
Claudio Bravo
Grisha Bruskin
Anthony Caro
Dale Chihuly
Vincent Desiderio
Richard Estes
Red Grooms
Israel Hershberg
Ignacio Iturria
Marisol
Raymond Mason
Tom Otterness
Beverly Pepper
Arnaldo Pomodoro
Larry Rivers
Guillermo Roux
Tomás Sánchez
Hunt Slonem
Clive Smith
Kenneth Snelson
The Estate of Jacques Lipchitz
The Estate of James Rosati

Marlborough Graphics
40 West 57th Street
New York, NY 10019
Telephone 212.541.4900
Telefax 212.541.4948
graphics@marlboroughgallery.com

London
Marlborough Fine Art (London) Ltd.
6 Albemarle Street
London W1X 4BY
Telephone 44.20.7629.5161
Telefax 44.20.7629.6338
www.marlboroughfineart.com
mfa@marlboroughfineart.com

Agents for:
Frank Auerbach
Christopher Bramham
Steven Campbell
Lynn Chadwick
Chen Yifei
Stephen Conroy
Christopher Couch
John Davies
Daniel Enkaoua
Karl Gerstner
Dieter Hacker
Maggi Hambling
John Hubbard
Bill Jacklin
Ken Kiff
R.B. Kitaj
Christopher LeBrun
Thérèse Oulton
Celia Paul
Sara Raphael
Paula Rego
The Estate of Oskar Kokoschka
The Estate of Victor Pasmore
The Estate of Graham Sutherland

Marlborough Graphics
6 Albemarle Street
London W1X 4BY
Telephone: 44.20.7629.5161
Telefax 44.20.7495.0641
graphics@marlboroughfineart.com

Santiago de Chile
Galería A.M.S. Marlborough
Nueva Costanera 3723
Vitacura, Santiago, Chile
Telephone 56.2.228.8696
Telefax 56.2.207.4071

Monte-Carlo
Marlborough Monaco
4 Quai Antoine 1er
MC 98000 Monaco
Telephone 377.97.70.25.50
Telefax 377.97.70.25.59
art@marlborough-monaco.com

Madrid
Galería Marlborough, S.A.
Orfila, 5
28010 Madrid
Telephone 34.91.319.1414
Telefax 34.91.308.4345

Agents for:
Juan José Aquerreta
Martín Chirino
Juan Genovés
Francisco Leiro
Antonio López Garcia
Javier Mascaró
Miquel Navarro
Pelayo Ortega
Daniel Quintero
Joaquín Ramo
Manolo Valdés
The Estate of Lucio Muñoz
The Estate of Antonio Saura

Important Works available by:
Impressionists and Post-Impressionists
Twentieth-Century European Masters
German Expressionists
Post-War American Artists

Marlborough Offices

Galería Marlborough
Acevedo 850
1414 Buenos Aires, Argentina
Telephone 54.01.777.0916
Telefax 54.01.777.0916

Marlborough Gallery AG
Spiegelhofstrasse 36
8032 Zürich, Switzerland
Telephone 41.1.268.80.10
Telefax 41.1.268.80.19

To Barry Rosen for over two decades of warm friendship and wise advice

This second edition of
Chihuly Marlborough
is limited to 15,000
perfectbound copies.

www.chihuly.com

Photographs
Parks Anderson, Theresa Batty,
Jody Coleman, Jan Cook,
Koei Iijima, Russell Johnson,
Scott Mitchell Leen, David Quinn,
Teresa N. Rishel, and Terry Rishel

Design Team
Anna Katherine Curfman,
Laurence Madrelle, and Barry Rosen

Paper
Manufactured by Smart Papers.
The cover is Kromekote*Plus* 12pt cast-coated.
The text is Kromekote*Plus* 6pt cast-coated.

Typeface
Avenir

ISBN 1-57684-032-8

Printing and binding
Paramount Graphics, Beaverton, Oregon